Kachina Dolls

Helga Teiwes

Kachina Dolls

The Art of Hopi Carvers

With Photographs by the Author

Historical Photographs by Forman Hanna

THE UNIVERSITY OF ARIZONA PRESS

Tucson

The University of Arizona Press
Copyright © 1991
The Arizona Board of Regents
All rights reserved
♾ This book is printed on acid-free, archival-quality
paper.
Manufactured in the United States of America
96 95 94 93 92 91 6 5 4 3 2 1

Library of Congress Cataloging-in-Publication Data
Teiwes, Helga.
 Kachina dolls : the art of Hopi carvers / Helga
 Teiwes ; with photographs by the author ; historical
 photographs by Forman Hanna.
 p. cm.
 Includes bibliographical references and index.
 ISBN 0-8165-1226-4
 ISBN 0-8165-1264-7 (pbk.)
 1. Kachinas. 2. Hopi Indians—Wood-carving.
3. Hopi Indians—Art. 4. Wood-carving—
Arizona—Technique. 5. Cottonwood—Arizona—
Social aspects. I. Hanna, Forman. 1882–1950. II.
Title.
E99.H7T38 1991
745.592′21′089974—dc20 91-13289
 CIP
British Library Cataloguing in Publication data are
available.

Contents

Figures

Preface

For years, one of the tasks of the Arizona State Museum has been to document the lifestyles of various southwestern Indian tribes through photography. A major component of day-to-day activities among these groups is the production of craft arts, which in themselves constitute a major subject for photography. Several years ago I urged the museum's administrators to consider updating our photographic records of contemporary Indian craft arts.

My suggestion for such documentation was greatly encouraged from the onset by R. Gwinn Vivian, the associate director of the museum. I also received encouragement and practical advice from John and Clara Lee Tanner and Emil W. Haury. Given limited time and travel funds, I thought it important to start with a small project. Discussions with Dr. Vivian led to my decision to concentrate on one art form within one tribal group. We settled on Hopi kachina-doll carving for several reasons, including the fact that the subject was of particular interest to the Tanners, who saw the importance of documenting the significant technological changes in an art form that was evolving rapidly.

Using contacts in Hopi villages that I had established over the years, in 1986 I began making trips

of five to eight days two or three times a year to the Hopi country to photograph and interview twenty-seven representative carvers at work. Dr. Haury generously donated funds to cover much of this travel, and Dr. Vivian and I applied for a grant from the Arizona Humanities Council to continue the work. Our grant was approved, but the council stipulated that the documentation be used for some direct public benefit. Accordingly, we planned a photographic exhibit that ultimately included not only my photographs but also a number of kachina dolls and the tools used to produce them. The need for an exhibit called for photographic coverage of a wider range of subjects than originally planned, as we now had to explain to the public the religious meaning of the *Katsinam,* the Hopi spirits; the role of the kachina doll in Hopi culture; and the technological development of kachina-doll carving. We also realized at this point that I needed to document a wider range of Hopi carvers, not just those who had contributed most to the transformation of this craft art to the sphere of "fine art." As a result, I made more trips than planned, the last in 1989.

Throughout this project I was encouraged and assisted by several individuals, most of whom also served as Arizona Humanities Council project advisers. Barton Wright, a leading authority on Hopi kachina dolls, helped with many details, as did John and Clara Lee Tanner and Emil Haury. Hopi scholar Emory Sekaquaptewa provided me with knowledge about Hopi religion, customs, and ceremonial activities. The assistance of Bruce McGee of McGee's Indian Art Gallery was also of great importance to me. Bruce gave me the names of several carvers who were and are instrumental in elevating their craft into the realm of

fine art. He has sold Indian art for more than twenty years, the last eighteen at Keams Canyon, where carvers come to him daily with creations to sell.

My knowledge of Hopi kachina-doll carving was not extensive at the start of this project, and I had to learn a lot fast. From Bruce I learned how important the carving style of Alvin James Makya and Wilfred Tewawina was in the 1960s. He pointed out Brian Honyouti's innovations of the 1970s and made me aware of the recent achievements of Cecil and Muriel Calnimptewa and the influence of their techniques on other carvers. I set out to find them, asked for their help, and branched out to find other carvers.

This documentation cannot include all the Hopi carvers in the market. To those whose work is not included, I can only apologize. Their exclusion in no way reflects on their work or creative talent but is instead a result of the constraints of time and travel funds, for the Hopi Mesas are three hundred miles from where I live and work. The carvers represented in this book are only a cross-section of the carvers who have been instrumental in the current state of their art. To all of them and their families, who gave so graciously of their time and knowledge, I wish to express my heartfelt thanks.

I am equally indebted to the staff of the museum's Public Programs Division, who designed and installed the public exhibit. Russell Varineau, associate curator, and Rhod Lauffer, preparator-designer, did much of this work, while Bruce Hilpert, curator of public programs, worked with Dr. Vivian in preparing the captions for the photographs and artifacts.

I particularly appreciate, of course, the time that all the Hopi artists devoted to making the project and

this book a success. Their enthusiasm for the project was displayed when sixteen of the carvers and their families attended the opening of the exhibit in Tucson. They spent two days talking to the public, displaying their dolls, and demonstrating doll carving. More than fifteen hundred visitors delighted in the chance to see and speak with the artists and purchase examples of their work.

This book is a direct result of the public exhibit. It reproduces many of the photographs in the exhibit but also gives a more detailed analysis of recent developments in Hopi kachina-doll carving and, most important, gives readers a chance to acquaint themselves with each participating artist.

Kachina Dolls

Hopi Life and Religion

Northern Arizona has been the home of the Hopi Indians for centuries, and archaeological evidence has established that they are the descendants of a people who inhabited the cliff ruins and pueblos in the area even earlier. The Navajo named these people the Anasazi, the Ancient Ones. Like their ancestors, the Hopi are masters of survival. Many outsiders have marveled at their ability to grow enough food to feed hundreds of people for centuries in this harsh and dry environment, where the annual rainfall is twelve inches or less. The soil is sandy and does not seem to contain the necessary nutrients to grow plentiful harvests. Perennial rivers do not exist where the Hopi live today, and the washes only run after heavy rains. Yet, in spite of such obstacles, the Hopi are outstanding farmers. They have developed the skill of dry farming, which requires only meager rain and snowfall. Provided that the land has been covered by a deep layer of snow, the sandy soil retains enough moisture to allow the freshly planted seeds of corn, beans, and squash to germinate despite many weeks of cloudless skies. With Hopi prayers and help from their deities, the rains come in the summer months to make the crops grow into good, often even plentiful, harvests.

Few would be able to survive in the desert of the

Colorado Plateau of northern Arizona. The region derives its name from the Colorado River, which has carved its way through rock formations for millions of years. The Little Colorado River enters the region from the high mountains farther south; on its banks large Hopi pueblos once thrived. The present-day villages are located on the Hopi Mesas, fingerlike extensions that protrude southward from Black Mesa, a large, high plateau stretching south from Kayenta. Eight thousand Hopi live in twelve villages spread over a distance of about eighty miles, from Moenkopi on the west to Keams Canyon on the east. The winters can be bitterly cold, the summers often extremely hot. Great temperature differences between night and day occur at any season.

Heavily eroded sandstone is underfoot everywhere, and mesa cliffs dominate the landscape. Most evenings, the sinking sun bathes them in warm, gold-tinged, spectacular colors. The vegetation is sparse; occasional junipers and pinyon trees reflect the lack of rain in their stunted growth; grasses, rabbit-brush, and clusters of squawbush grow among the rocks. Larger Hopi fields lie below the mesas in level areas where floodwater from the washes can reach them. Here farmers dig small ditches to lead the rainwater to their plants, for there are no wells or irrigation canals. In sand dunes on the slopes of the mesas and in washes between them stand small fields, orchards of peach and apple trees, grape arbors, and terraced gardens.

Caring for the fields and plants, harvesting the crops, and storing and preparing food are constant activities in Hopi life. Daily work centers on food production and storage, as dictated by centuries of strug-

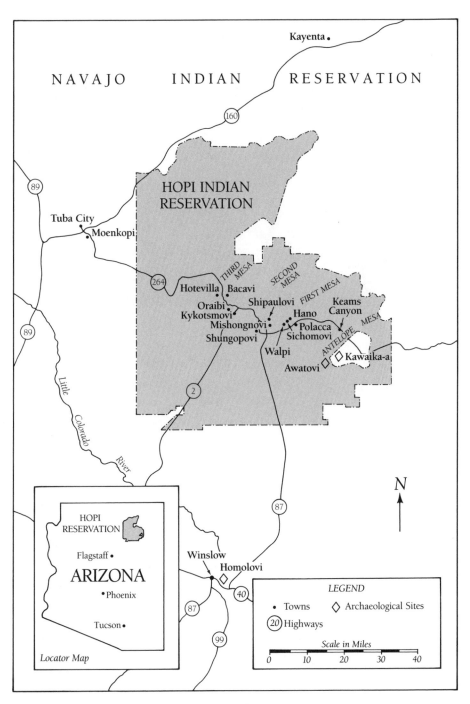

The Hopi Reservation

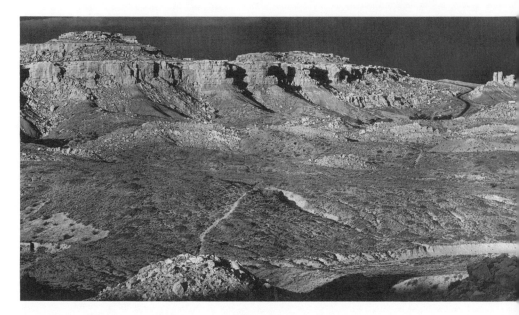

Second Mesa. Shipau-lovi is located on the mesa on the rocky hill at left, and Mishong-novi is on a similar hill in the center.

gle for survival, and their rich and complex ritual life is tied to the dictates of the seasons.

The Hopi have traditionally lived in contiguous, multistoried structures built around one or several plazas and underground ceremonial rooms called kivas. Their building material has always been stone, usually sandstone cut into large rectangular blocks and bound with clay mortar. Room interiors are usually plastered and whitewashed, with the labor often done by women, who own the houses. Heavy beams brought from the distant higher elevations on Black Mesa support ceilings of smaller branches, brush, and dirt. This construction is either the flat roof of a house or the floor of a multistory structure. Formerly, outside ladders were used to enter the upper rooms. Very few multistory houses are left today, in Walpi on First Mesa, Shungopovi and Mishongnovi on Second Mesa, and Oraibi on Third Mesa. In times past the Hopi also lived below the mesa tops, but they abandoned

their lower villages three hundred years ago because of their fear of Spanish reprisals for rejecting their Christian missionary efforts.

The key to the Hopi talent for survival is their adaptability to change. Today, recently constructed housing is again appearing in the flats below the mesas. The houses are of modern American style,

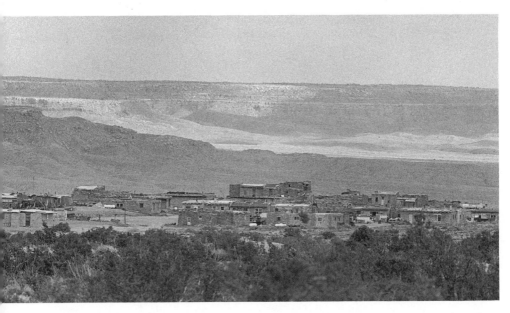

The village of Oraibi on Third Mesa is the oldest continually inhabited settlement in the Hopi country.

many of them built with financial support from the federal government, with grassless front yards leading to paved streets. In suitable locations below the mesas there are also grocery stores, tribal government buildings, and schools—structures that need an expanse of flat ground. If there is room on the mesa tops, large buildings are set back at a safe distance from the precipice. Modern architecture and such conveniences as service stations and satellite dishes have been incorporated into Hopi life. To casual Euroamerican visitors,

the scene appears not too different from their own cultures.

But what no outsider who is unfamiliar with the Hopi can see, what sets them apart from all other American Indians and holds the Hopi people together is their way of dealing with the world around them. The Hopi have refused to have their religion taken away from them. They believe in living their own way, the Hopi Way. They call themselves Hopíitu, the friendly or peaceful people. The Hopi overcome difficulty and adversity not by aggression and open conflict but by considering all the elements in nature and adapting to new situations in a nonviolent manner. Living this way takes spiritual strength, which the Hopi seek in complex religious ceremonies and prayers to their deities, whom they approach through intermediaries.

These intermediaries are the Katsinam,* the Spirit Beings of the Hopi world. Hopi scholar Emory Sekaquaptewa says that "the katsinam are the heart of Hopi life." They are the beings to whom all Hopi look for direction, heed, and give their prayers for the continuation of life—not only their own life but also life in general, for Hopi benedictions include all life on this planet.

To the Hopi, all things are imbued with life. Like people, animals and plants have spirits, but so do rocks, clouds, water, and earth. Each entity in the

*In this book, the term *Katsina* refers to the spirit itself (plural: *Katsinam*), and *kachina* refers to the doll carved to depict the spirit. Hopi proper names and descriptive terms are frequently used in this book in order to familiarize the reader with the subject. English translations are provided whenever possible, and a glossary at the back of the book serves as a guide to the more common Hopi terms.

universe is represented in the spiritual world of Hopi thought, and each spirit is important at one time or another, for each can carry prayers to the deities.

The Hopi have a great respect for the Katsinam, who are with them for six months of the year. They welcome them into their villages at the beginning of their ceremonial cycle, in the depths of winter, and then regulate their social life and behavior accordingly. Before each ceremony the women prepare huge amounts of food to feed the Katsinam during the days of religious activities. The Katsinam, who are a part of the Cloud People, bring rain to the Hopi country.

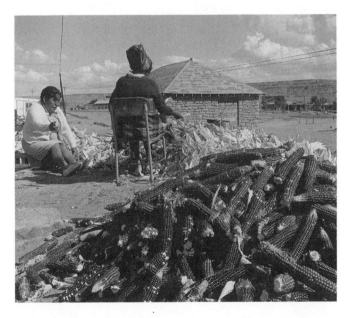

Blue corn, a particularly valued food for ceremonies, is husked after harvesting. Shown here are Marietta Tewa and her neighbor.

Hopi ancestors, in Hopi belief, have joined the Cloud People; together with the Spirits, they return to the Hopi villages, providing lifegiving moisture to the parched land. The concepts of continual life and fertil-

ity are basic and are particularly important to the Katsinam.

Growth and fertility are symbolized in every Hopi ceremony, particularly the Powamuya ceremony, which is held in February at the beginning of the ceremonial cycle. When the winter cold forces all plants into dormancy, new bean plants are begun in the kivas. Men are put in charge of keeping the fires going to stimulate the germination and growth of the bean seeds. Under the watchful eyes of the Katsinam, the bean plants sprout. Then the Powamuya ceremony is announced, and the spirits bring the young plants out of the kivas. The health and abundance of the bean sprouts grown in the kivas portends the success of that year's crop. All Hopi ceremonies are held far in

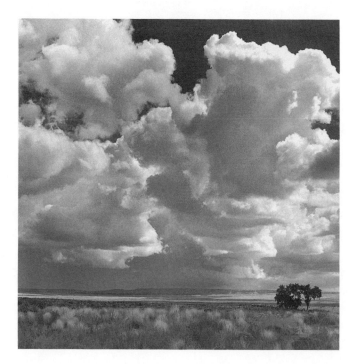

Cumulus clouds, harbingers of summer rains, gather over the Hopi country between First and Second Mesa.

Gifts of the Spirit World, freshly cut bean sprouts, still tied to the kachina dolls that were given by Katsinam. The bean sprouts are a symbolic portend of a plentiful harvest to come. Later that day they will be untied, cooked, and eaten as a green vegetable.

advance of the actual event, thus enabling the prayers for rain to reach their destiny before the clouds of summer storms form, or before winter storms bring snow to cover the land. The anticipation of coming events and the preparation for them activate Hopi life. Most of these events are agricultural in nature and are tied to the annual cycle of the seasons for planting, growing, and harvesting: the essentials of life's sustenance. In close relationship, of course, are the cycles of fertility, health, and happiness of the people.

There are more than 400 known Katsinam. Some of them, the Mong Katsinam, are very old and important and do not change in their appearance, though they may not be seen on all three mesas anymore. Other Katsinam may have been coming to the villages since a time beyond memory, yet their functions have been forgotten. Then there are those that may be only

a few years old or that can be seen only infrequently or that appear only in certain villages. Some are more popular than others. A great number are firmly tied to certain ceremonies and appear at the time of these ceremonies each year.

The Katsina Season and Ceremonies

Katsina rituals are directly linked to the seasonal demands of agriculture. Just as each month involves a certain farming activity, so too does each month form part of the calendar of ceremonial events. Even though religious ceremonies are performed throughout the year, the Katsinam appear only from the winter solstice on December 21 to the middle or end of July. For these six months they live with the Hopi people, performing ceremonies for them in the kivas during the cold winter months and dancing in the plazas in spring and early summer for the enjoyment of all.

The first Katsina to arrive is the Soyalangw Katsina on Third Mesa, who announces the celebration of the winter solstice and the gradual return of the sun. At the Powamuya ceremony in February, other Katsinam appear in the villages. Powamuya brings new hope to the people, hope for the beginning of new life and for the extension of life in progress. The aspect of fertility is expressed in the growth of bean sprouts, in the behavior of the Mastop Katsina, and in the gifts presented to the children and women. Little boys receive symbols of fertility in the form of lightning bolts, indicating rain. These are carved from wood and

Each month of the year has important ceremonial activities, but the Katsinam visit the Hopi villages only during the six months from the winter solstice to the middle of July. (From Wright, Barton. Kachinas: A Hopi Artist's Documentary, *p. 258)*

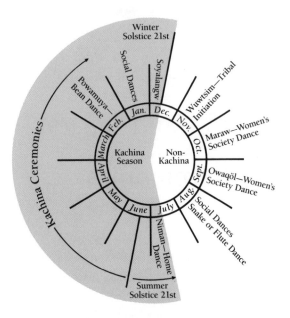

are painted in the colors of the six directions. The boys also receive bows and arrows, symbols of provision. Some of the women, but mainly the little girls, are given kachina dolls called *tithu* (sing.: *tihu*), small representations of Katsinam carved out of cottonwood root.

At sunrise on the last day of the Powamuya ceremony, two Katsinam from each kiva in the village appear and distribute their gifts. They may be assisted by Runner Katsinam. Each Katsina knows exactly which doll or bow and arrows to give to which child. When they approach the family, the women sprinkle sacred cornmeal in front of or on the Katsinam, greeting them by symbolically feeding them. Bean sprouts are tied to each gift the spirits bring, and the women may untie additional bean sprouts from the headdress of a Katsina, thus increasing the blessing on their houses. Later that day, each family will boil and eat the sprouts.

The night before this sunrise ceremony, hardly anyone sleeps. The adults are busy with preparations, and children lie awake in anticipation. Hopi relatives travel from afar to arrive in time to witness and receive the blessings of the Katsinam. The early February morning is often very cold, and the children, still half-asleep, are wrapped in large shawls. Patiently waiting for the arrival of the Katsinam, the Hopis stand on hard, frozen ground or icy snow with freezing feet and shivering bodies. But once the spirits appear, all their discomfort is forgotten. The spirits are often naked to the waist, their upper bodies painted, seemingly impervious to the cold.

Late that night the Katsinam appear at the kivas to dance for the people. Below, in the kiva, the women sit facing the huge entrance ladder. After announcing themselves from above, the spirits enter the kiva, descending the huge ladder. One Katsina takes on the function of drummer to accompany the singing and

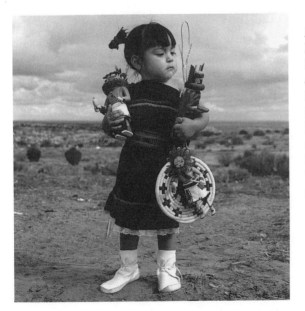

Kelly Shupla, two years old, holds the gifts that the Katsinam brought her at the Powamuya ceremony in February 1989 in Bacavi. In her right arm she is holding a Qa' ökatsina (Corn) kachina doll, and in her left arm an Angwushahay' i (Crow Mother) kachina doll and a Taawakatsina (Sun) kachina doll tied to a coiled basket.

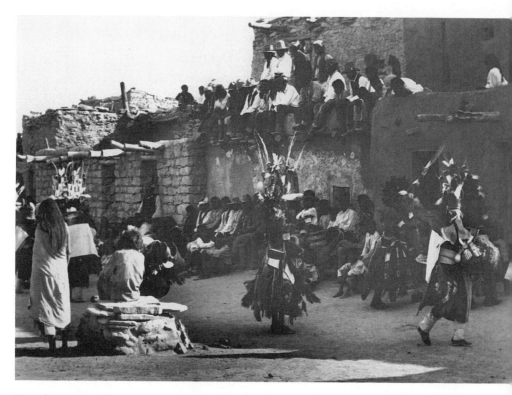

Hemiskatsinam and Katsinmamant distribute their gifts to the children. (Mishongnovi, July 1922; photograph by Forman Hanna)

rhythmic dancing of the others. Their presence is powerful, heightened by the closeness of the room and the sound of feet stamping in unison, by the body movements and guttural singing, by the sounds of many rattles and the beating rhythm of the big drum. All this translates the vibrant ceremony into the dominance of life. Between dances the Katsinam distribute more gifts, sometimes tithu, baskets, or other bows and arrows but more often fruit, large cookies, or handfuls of seeds. Distributing seeds is an act symbolic of prolonged or new life; the seeds mean the continuation of the Hopi. Every person leaves the kiva with a feeling of being blessed and with inner satisfaction.

Besides the Katsinam who are benevolent in char-

acter, there are also disciplinary Katsinam, who watch over the people to see that they maintain an honest life of hard work. When these Katsinam appear during the Powamuya ceremony on Second Mesa in February, their gestures and behavior make a fearsome sight indeed. A group of fourteen to sixteen Katsinam goes from house to house in the village, making sure that little girls know how to grind corn, little boys how to provide food and meat. The fierce Nata'askam, with their huge mouths and wicked teeth, stand in the back, making loud, threatening noises and demanding food from the household under threat of taking the children away. Many a child has screamed in horror at the sight of the big knife, the saw, the crooked cane, and the large child-sized baskets that some of the Katsinam carry on their backs. Parents plead with these spirits not to take the children. They hand over food, and today soft drinks, to make these spirits leave their family alone. Appeased, the Katsinam turn to the next house and the onlooking villagers, who, having kept a safe distance, flee indoors, their fear expressing the real possibility of being caught by the lassos of the horrifying Mots'in Katsinam. Everyone runs until it is clear which house is targeted next. Adults, too, can earn the wrath of the spirits if they have neglected such duties as cleaning out springs and ditches to assure the flow of clean water. Even though these Katsinam appear formidable as disciplinarians, they undertake their tasks for the benefit of the village.

At the Niman Dance in July, the Katsinam appear for the last time before they return to the San Francisco Peaks near Flagstaff, where they live in the Spirit World for the rest of the year. For that reason the Niman Dance is also called the Home Dance. From the

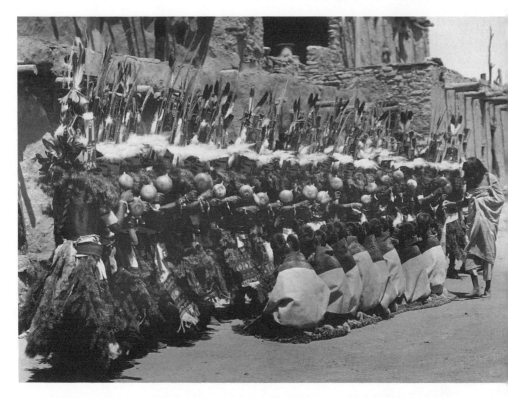

A long line of more than thirty Hemiskatsinam dancing and shaking their rattles while the Katsinmamant kneel in front of them, playing a rasping instrument. (Mishongnovi, July 1922; photograph by Forman Hanna)

precipices of the village locations, these mountains loom over the high plateau that stretches between, reminding the people constantly of the mountains' sacred character as the dwelling place of the spirits.

July is the time for the first corn to be harvested, and the Katsinam bring it into the plaza at the Niman Dance. The spirits have helped to bring the seasonal food production cycle this far, and now all are rewarded with the first fruits of the year's labors. The size of this early harvest is good indication of the major harvest two to three months hence.

The Hemiskatsinam dance in the big plaza, their rhythmic singing in deep voices echoing off the house walls. The Hopi spirits sing for rain, health, long life,

and fertility. They dance in a long line of stately fig-
ures, turning at particular verses of the song and shak-
ing gourd rattles to the beat of their feet. They are a
spectacular and awe-inspiring sight. The long line of
forty or more Katsinam repeats its songs three more
times while it moves throughout the plaza, indicating
the cardinal directions. Women of the community
walk by and sprinkle the Katsinam with sacred corn-
meal, thus feeding the spirits. The dance leader stands
outside the line and indicates the changes in verses
and rhythm. They sing:

Qotsaqa' omana
Qootsap qaaoo maanatu
sakwaap qaaoo manatuu

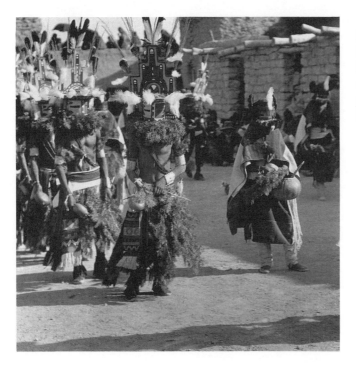

Hemiskatsinam and Katsinmamant at the Niman Dance. (Mish-ongnovi, July 1922; photograph by Forman Hanna)

Umuungem natuuwaniwa taal' aangwnawita
Uraa aawupoq yookvaaniqoo
aatkyaaqw suuvuuyooyangw uumumii pew
yooyhoyooyootaangwu

White Corn Maiden
White corn maidens,
blue corn maidens,
for your benefit they are raised in the growing
 season.
As you know, when it is going to rain all over the
 land,
from down below a steady rain comes moving
 toward you,
the rain moving along steadily.

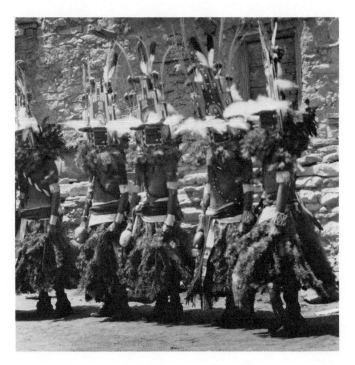

At the Niman dance the imposing grace of the Hemiskatsinam is enhanced by their tall headdresses. (Mishongnovi, July 1922; photograph by Forman Hanna)

Symbolic designs and motifs of fertility are painted on the Katsinam's headdresses, which are stepped wooden *tablitas* painted in the six directional colors, their height increased by imitation corn tassels and the downy feathers of eagles. The tallness thus achieved makes the spirits appear truly superhuman, seemingly bringing them closer to the sky, as if they were reaching for the longed-for rain clouds. Their

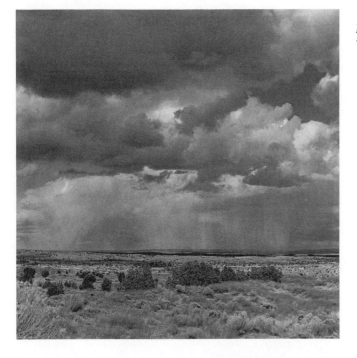

Rain clouds hover over Third Mesa.

singing and majestic dancing is so powerful that it is easy to believe that their prayers for rain will be heard by the deities. The hope of the whole community is embodied in the long hours of singing and dancing, a hope that plenty of rain will fall on the growing crops so that the harvest of food in a few months will be

plentiful—and in a broader sense, a hope for life-giving grace in general.

The Katsinam leave when the first thunderheads form at the end of July, assuring the Hopi that nourishing rain will soon fall.

The Antiquity of the Katsinam

To understand the meaning of the Katsinam and the kachina dolls, it is necessary to understand Hopi culture, because one does not exist without the other. The question naturally arises, How old are the Katsinam, the spiritual leaders of the Hopi? To answer this question, Hopi culture must be traced back into prehistory, which is what archaeologists have been doing now for several decades.

They have found that the Hopi's main ancestors were the Anasazi, a group of people who at about the time of Christ came to depend on agriculture. They were located in what is now called the Four Corners region, and they lived in semisubterranean dwellings called pit houses. By A.D. 700 they had built houses above ground in adjacent clusters, which over time developed into the typical pueblo structures. From A.D. 1100 to 1300 they expanded into large areas of what is now Arizona, New Mexico, Utah, and Colorado. Archaeologists call this phase Pueblo III, the time of the large pueblos like Cliff Palace, Pueblo Bonito, Aztec Ruin, Betatakin, and Keet Seel. All these pueblos have large numbers of kivas. Each kiva has a symbolic

representation of the Sipàapu, the hole to the under-
world from which the Hopi believe they came and the
pathway to the upper spiritual world, the symbol of
emergence in Hopi belief. As in modern Hopi kivas,
the prehistoric structures had a fireplace or stove with
a heat deflector, benches along the kiva walls, and
niches for ritual objects. Then as now, the entrance
to the kiva was by a ladder through the roof.

Archaeologist J. O. Brew argues that the ancestral
Hopi lived in the same region where the Hopi live
today since late Basketmaker and early Pueblo times,
that is, beginning about A.D. 300 to 400. Excavated
villages of that time reveal cultural materials similar
to those now used by the Hopi. Hopi oral history and
some archaeologists agree that by the thirteenth cen-
tury the Hopi ancestors had spread over a large area
from the Grand Canyon to the Flagstaff area, north
of Black Mesa, and south to the Little Colorado River.
No archaeological evidence of the Katsina religion
has been found in these early habitation sites, but great
changes did occur during the thirteenth and fourteenth
centuries. Archaeologist E. Charles Adams has exca-
vated large ancestral Hopi pueblos in the Little Colo-
rado River valley north of Winslow over the last
several years. According to his findings, the Katsina
religion had a major influence on Pueblo culture after
A.D. 1300.

The ceremonial custom of representing supernat-
ural beings may have been introduced into the Hopi
area from the south. James S. Griffith suggests a con-
nection to Casas Grandes in Chihuahua, Mexico,
which served not only as a trading center but also as
a center from which ceremonial beliefs from Mexico
may have spread northward. Adams thinks that by the

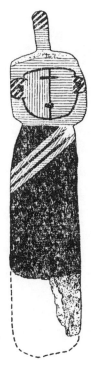

This cottonwood carving is the earliest recorded wooden artifact resembling a carved kachina figure. It is 7¾ inches high. The carving clearly delineates a head with a headdress from a body without limbs. The face is divided into a blue left side and a red right side. Earplugs and the top of the headdress are dark green. The three diagonal stripes across the body are light green and red and resemble the bandolier worn by modern Katsinam. The artifact was excavated by Frank Hamilton Cushing on the Hemenway Expedition in 1887–88 at the Double Butte Cave, the site of a prehistoric shrine, at the location of present-day Tempe, Arizona. Emil Haury dates the carving to the thirteenth to fourteenth century (Haury, "Excavation of Los Muertos," p. 199).

twelfth century the Katsina religion had developed in the upper Little Colorado valley, where groups of Mogollon people lived. Excavations have revealed potsherds from Casas Grandes that show ceremonially clad beings with masked faces. Polly Schaafsma found similar evidence in the Rio Grande Valley dating from about A.D. 1350.

The dissemination of any successful ideology or religion can be attributed to a certain need among people and to its usefulness to those who influence that people's behavior. Adams looks further into the prehistoric developments that made the spread of the Katsina religion possible if not necessary. From tree-ring dates we know of a great drought in the last quar-

ter of the thirteenth century in the area populated by the Pueblo people. Some scientists find reason in this climatic disaster for the abandonment of the large pueblos. Others, like Brew, find an additional reason in the pressure exerted on Puebloan groups by the arrival from the north of tribes like the Navajo, Apache, and Ute. What Charles Adams discovered in his excavations at Homolovi is that the population we now call the Hopi increased rapidly due to an influx of people from drought-stricken areas farther north. After A.D. 1300, new rooms were added to existing pueblos in the Little Colorado area as well as to structures in the Flagstaff area like Elden Pueblo, and large rectangular kivas were built and plazas enclosed by houses to accommodate the increased population.

Spiritual beings in human form with either heavily painted or masked faces now began to appear on pottery more frequently, suggesting that the Kat-

The face of the Qöqlö Katsina on a ceramic bowl. This pottery type is called Pinedale Black on White, and it belongs to the Mogollon Pueblo Culture. The bowl dates from the late fourteenth century. It was found in the Roosevelt Lake area and is in the collection of the Arizona State Museum in Tucson.

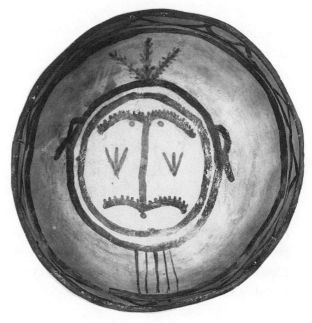

sina religion had increased its influence in a time of
great need. A much larger population had to be fed
with the produce from less farmland, and only the
coordinated effort of each person could make possible
the survival of everyone.

Religion provided the matrix for this cohesion,
and the Katsina religion involved every man, woman,
and child. Even today every Hopi is initiated into the
Katsina religion, thus uniting members of different
clans and religious societies. One of the major charac-
teristics of Hopi society is that individualism is deem-
phasized; the interest of the community is always
placed before that of the individual. The Katsina reli-
gion has a great deal to do with this attitude: men
spend days preparing for the ceremonies in the seclu-
sion of the kiva, while women prepare food for the
ceremonies to feed the Katsinam and other villagers.
Women also weave baskets and make pottery as gifts
for the Katsinam, as all farming activities are pursued
only with their blessings. The Katsina religion has per-
meated Hopi life ever since it gained prominence in
the fourteenth century and has provided the unity that
has given the Hopi the strength to overcome great
obstacles.

Hopi ceremonies have a unifying effect on the
whole community. Katsinam, being benevolent spirits,
also transmit a peaceful attitude: aggressive behavior
is not tolerated among the people, and the natural
elements are petitioned by prayers to be nonviolent
to their crops.

Frederick J. Dockstader has identified many
kachinalike petroglyphs or pictographs, which are
difficult to date. Occasional pottery fragments with
Katsina representations had been found prior to the

Homolovi excavations, although in the late 1920s C. B. Cosgrove found wooden artifacts representing the Katsina religion in the Upper Gila drainage of New Mexico. The esoteric nature of the Katsina religion poses difficulties for anthropologists in finding material evidence of Katsina costumes in excavations or abandoned dwellings. The sacred material is closely guarded and cannot easily be dated.

An early report of Katsina representations is the 1681 account of the Spanish lieutenant general of cavalry Juan Dominguez de Mendoza. In his report of the Spanish reconquest of the Indian pueblos in New Mexico, he stated that he entered the deserted pueblo of Puaray in early December of that year and found many "masks de cacherias, in imitation of the devil, which are those they use in their diabolical dances." The Spanish burned all of them. In *The Kachina and the White Man,* Frederick Dockstader cites this and many other Spanish documents that mention Pueblo ceremonies and masks.

The representations of masked beings that are the easiest to identify as Katsinam come from kiva murals. In 1935 Gordon Vivian excavated such murals in a kiva in the pueblo of Kuaua, north of Albuquerque. The pueblos of Kawaika-a and Awatovi were excavated by the Peabody Museum of Harvard University under the leadership of J. O. Brew, also in the 1930s. These pueblos are located on Antelope Mesa, close to First Mesa, and date to about A.D. 1300–1600. While Kawaika-a was abandoned before the arrival of the Spaniards, Awatovi was a large pueblo at that time, and the Hopi allowed missionaries to enter. Watson Smith, who helped excavate the ruined pueblo in 1935, found the remnants of a Spanish church that

had been built in 1629, dedicated to St. Bernard of
Clairvaux and named San Bernardo de Aguatubi.
Directly under the main altar Smith found a kiva filled
with sand that had preserved the lower two-thirds of
wall murals painted a year before the Christian church
was built. He found four layers of murals made
between 1600 and 1625, indicating the Hopi habit of
painting over kiva murals after their usefulness had
expired. At Awatovi earlier murals had been covered
with layers of plaster, while today they are washed off
the walls. The last layer of murals showed masked
human figures that can be identified as particular Kat-
sinam by Hopi elders today.

Spanish missionary efforts expanded to four
other Hopi villages besides Awatovi but were of no

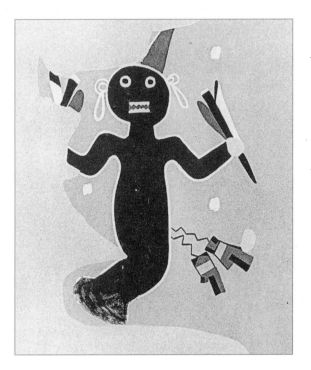

*This sixteenth-century figure is
from a remnant of a kiva mural
in Awatovi, a former Hopi vil-
lage. Its mouth, white eye circles,
and black body paint resemble
the modern Hopi Katsinam
Nata' aska, So' yoko, So' yok
wuuti, and So' yokmana. The
figure apparently had a head-
dress of red feathers.*

This very interesting early-seventeenth-century figure from an Awatovi kiva mural painting excavated by Watson Smith resembles the Hopi Katsina Ahöla, a Katsina that appears at the Powamuya ceremony in February.

lasting effect. In fact, Pueblo resentment of the Spanish brought on the only time in known history that all the Pueblo tribes banded together. In 1680 they concluded that they had suffered enough under Spanish rule and revolted against their foreign conquerors. The Hopi, who had had relatively little contact with the Spaniards, participated in this revolt, but when the Spanish forces finally managed to reconquer New Mexico in 1692, the inhabitants of Awatovi welcomed back the priests. The rest of the Hopi were aghast. In a rare incident of violence, in 1700 they stormed Awatovi, killed all the Christians—whites and Hopi alike— took women and children with them to other villages, and razed the pueblo, which has been in ruins ever since. The Katsinam had won out.

In 1848, at the close of the Mexican-American War, the Hopi country became American territory. The isolation that had helped the Hopi maintain their reli-

gion and culture now began to be broken. In 1850 an American government agent, Dr. P.G.S. TenBroeck, visited Fort Defiance and bought a flat kachina doll there, the first historical account of a kachina doll.

Outsiders from the white world brought useful things like wheat, sheep, horses, and silver, but they also brought smallpox, which killed several hundred Hopi in 1853 and 1854. Many of the survivors fled to their Zuni neighbors. Periods of drought followed, which reduced the population in Oraibi, for example, from eight hundred to two hundred. Many more Hopi died in a renewed smallpox epidemic between 1866 and 1868. Again, the Zuni pueblo was the Hopi's place of refuge. This repeated contact with the Zuni produced a marked influence on Hopi pottery designs, language, and religion. Zuni and Rio Grande Katsinam were introduced into Hopi ceremonies at this time.

After the Atlantic and Pacific Railroad was completed through Arizona in 1881, the new towns of Flagstaff, Winslow, and Holbrook sprang up, bringing more whites to the region and to Hopi country. Among them were salesmen, tourists, traders, and in increasing numbers, Mormon missionaries. Mormon settlers began to encroach on Hopi land, often claiming those sites that had springs and washes. Because of such actions, the missionary efforts of the Mormons failed, and resentment among the Hopi grew rapidly. President Chester A. Arthur's establishment of the Hopi Reservation in 1882 ended white expansion, but the Navajo expanded and started their slow but steady movement toward the Hopi Mesas.

It was in these years that Hopi unity began to disintegrate. The Oraibi split of 1906 was a direct result of the friction within Hopi society, which was

torn between those who favored traditional ways of living and isolation from other cultures and those who concluded that the Hopi could survive only by acceding to the foreign government in Washington. Hopi children were already being forced to attend government schools with white teachers and to learn an alien tongue.

Between 1910 and 1920, Hopi ceremonies came to be a great attraction for eastern tourists, who traveled to the Southwest by railroad and then to the Hopi villages by car. Hordes of photographers sought to outdo each other for the best shots while intermingling with Katsina dancers. To these outsiders the very essence of Hopi life and culture was but a casual entertainment.

Hopi perseverance won out once again. Hopi elders protested, and for the last seventy years no photographs have been allowed to be taken at any ceremony. The reaction has gone so far in recent decades that whole villages are closed to whites from time to time, and non-Hopis may no longer attend certain plaza ceremonies.

In the 1970s and 1980s the number of Katsina dances increased despite the fact that most Hopi men by then earned their living in a wage economy. Inter-clan regulations and obligations for food preparation and ceremonial gift-giving are still observed, but now these activities are adjusted to fit the needs of holding a job, attending school, or running a business. Ceremonies may not be held precisely according to the positions of the sun or moon, as in the pre-wage economy, but are instead held on weekends, when the people have time to participate. Today, as in the centu-

ries before, the blessings of the Katsinam are sought, prayers are sent to the deities, restrictions are observed, and young children are initiated into the Katsina religion. The Hopi Way endures as the uniting force of the Hopi people.

Tithu: Kachina Dolls

Tithu, or kachina dolls, are small, carved wooden representations of the Katsinam. A kachina doll is not a Katsina, a spirit; the word *doll,* although inexact, should always be used to differentiate between the object and the spirit. A kachina doll in itself is not idolized or worshipped, but it does require respect, and if given by a Katsina as a prayer, it belongs traditionally within the realm of Hopi religious ritual. The fact that it is, in Hopi belief, made and given by a Katsina establishes a link to the spiritual world and thus represents well-wishing for the recipient. Seldom played with, these dolls, which usually have no bases to stand on, are hung on the wall of the family room, where they remain, treated respectfully, as blessings to the girl to whom it was given and her family.

According to Hopi tradition, kachina dolls are carved by the Katsinam, the Spirit Beings, when they spend their time in the kivas of the Hopi villages. It is they who also distribute them to the children and sometimes to Hopi women, most often at the Powamuya ceremony in February and at the Niman ceremony in July. To fulfill the demand for tithu by collectors and tourists, however, Hopi men have increasingly carved dolls for commercial purposes.

Tithu, dolls, have always been carved from cotton-

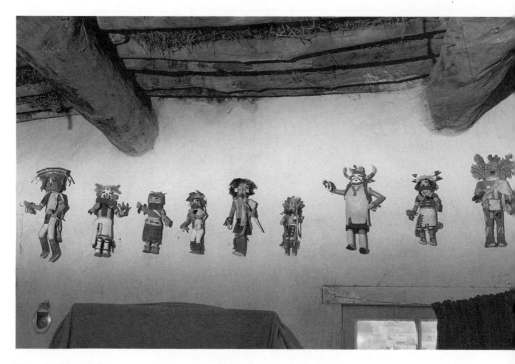

These kachina dolls, gifts of Katsinam, belong to a Hopi girl and grace the wall of her home in Oraibi.

wood root. The root is used instead of the branches because it is of denser consistency and will not crack as often. Most of all, it is easy to carve. The root should be from a dead tree, because the wood has to be dry and preferably should contain little or no sand that had been absorbed with the water while the tree was still alive.

In the past, Hopi men found their wood in washes below the mesas and in the rincons separating mesa cliffs, where water runoff provides moisture for the trees to grow. Unfortunately, on the Hopi Reservation sources of wood have disappeared in recent years due to the lack of moisture and increased demand. These days, most of the carving wood comes from off the reservation. Many carvers collect their own wood from the banks of the Little Colorado near Winslow or

its reaches to the west. Others find it the old way, by taking their horses into remote canyons, often while looking after their cattle or sheep.

Until recently, whites and Navajos also brought cottonwood root by the car- or truckload to the Hopi Mesas for sale to the carvers. Beginning in 1990, however, white suppliers were required to pay a yearly bond of $500 and a $25 permit fee to the Bureau of Indian Affairs, as well as a $200 fee to the Hopi Tribe, which, according to Hanks, ended their trade. Navajo suppliers still travel from village to village, selling wood directly to the carvers they know. The carver

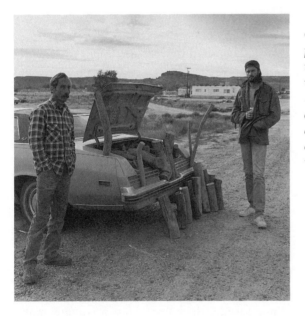

Gordon Hanks and a friend sold pieces of cottonwood root to many carvers on the Hopi Mesas until 1990. Most pieces were ten to fifteen inches in length and averaged three to five inches in diameter. The wood shown here came from the Verde River valley.

who can sell his dolls for good prices seldom collects his own wood, because his time is more profitably spent in carving. Naturally, such carvers are very particular about the wood they buy. They need large roots, because their action dolls require a large-

diameter block to start with. Some carvers have tremendous pieces of cottonwood root in their backyards, pieces that are as much as two feet in diameter and up to eight feet long. These are kept like treasures, covered with tarpaulins to slow the drying process and thus prevent them from cracking.

The northern Navajo Reservation, close to the Utah border, is full of nearly inaccessible deep canyons with beautiful stands of cottonwood trees, but only those who were born in the area know it well enough to find these treasures. Of course, the prices for such large pieces are high, and only those carvers who rank high on the collectors' lists can afford to buy them.

Smaller pieces are brought in from the Verde River valley of Arizona or from Utah and Colorado. Much driftwood, washed in from the upper reaches of the Colorado and San Juan rivers, can also be gathered by boat in the coves of Lake Powell. To distinguish the roots from the branches is easy, I am told, since the root is very smooth, whereas the branches are full of knots. The quality of the wood differs and is often hard to judge from the outside. Occasionally, after many hours of work, a carver might cut into embedded sand crystals that can hamper his efforts and even make completion of the doll impossible. Most of the time, however, experienced carvers can see in the crosscut of the wood if it is smooth or "full of rocks."

Carvers who can afford it stockpile wood that will last them for months. Others, less fortunate, make use of every small piece of wood they can find, sometimes rummaging through other carvers' discards. Even though capable of producing dolls carved out of one piece of wood, they may revert to the technique of

carving limbs and ornamentation from smaller pieces
and then gluing them to the doll's body.

The fact that cottonwood root has become scarcer
has prompted a few artists to venture into carving
other woods. Pine, for example, is readily available,
but it cracks easily and is too hard. Some carvers have
tried cedar, also a harder wood. Cedar is difficult to
work, and its reddish-brown tone differs substantially
from the pale cottonwood. Balsa wood approaches
cottonwood root in softness but is not locally avail-
able. Aspen has been tried, but it grows only above ten
thousand feet and is therefore hard to obtain. Rarer
still is the root of the walnut tree, even though a carver
who tried it, Leslie David, liked it very much, equating
it with cottonwood root.

As long as cottonwood root is available, carvers
will use it, because of both religious tradition and
the ease with which it can be worked. Cottonwood
belongs to the poplar family, and its fast growth—
provided that rain comes regularly—should ensure a
sufficient supply for kachina-doll carving. After all,
cottonwood trees and the product they share with the
Katsinam, the tihu, are a link in the everlasting cycle
of the Hopi Way.

All ceremonial gifts have to show the fundamen-
tal colors in specific areas, with each color indicating
one of the six directions. Yellow symbolizes the north-
west, blue-green the southwest, red the southeast,
white the northeast, and black the Zenith; these colors
mixed together indicate the area below the ground.
Not long ago a tihu had to be painted over its whole
body and decorated with the colors of the cardinal
directions, but with the appearance of new techniques

A putsqatihu is a flat kachina doll usually made for infants. It represents the earliest stage of fetal development. The dolls shown here depict Hahay' i wuuti (Katsina Mother). The doll on the left was collected before 1929. At right is the same kachina made in 1988 by Henry Shelton.

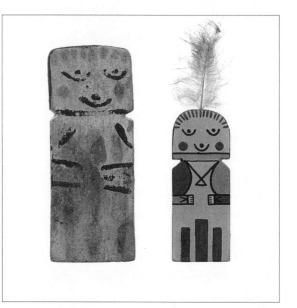

The putstihu taywa' yta represents the second stage of fetal development. It has a flat body, but the face is more three-dimensional than that of the putsqatihu. The Qa' ökatsina (Corn) putstihu taywa' yta on the left was collected in 1919. It is nine inches high and is in the Arizona State Museum collection. The Honani (Badger) kachina doll on the right is a modern putstihu taywa' yta carved by James Selina in 1988. It is eight inches high and is meant to be hung on a wall.

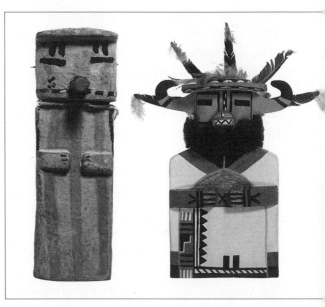

and styles in surface treatment, this requirement is
no longer strictly observed.

According to Emory Sekaquaptewa, the Hopi
recognize four forms of tihu, which represent various
stages of postnatal development. The word *tihu* means
child; thus these small replicas of the Katsinam are
the children of Katsinam. Infants, being in their first
stage of development, receive as gifts flat figures,
putsqatihu, which can be hung on cradleboards. Both
boys and girls receive putsqatihu. Toddlers receive
putstihu taywa'yta, dolls with flat bodies and more
three-dimensional faces. They represent the second
stage of fetal development. At the third stage, Katsi-
nam present the girls with *muringputihu,* figures with

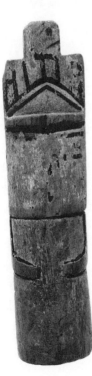

*The muringputihu doll has a cylindrical, very stylized
body and a fully carved head. It represents the third
stage of fetal development and is made for young girls.
This Hemiskatsina kachina doll, made before 1900, is ten
inches high and is in the Arizona State Museum
collection.*

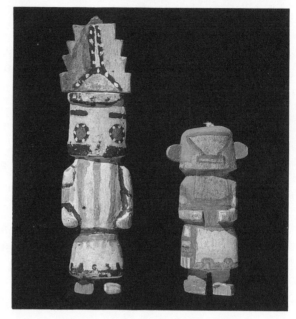

A tihu has a fully carved head and body and represents the final stage of growth. It is made for young girls and women. These two are carved in the Early Traditional style. They have stylized bodies with rudimentary carved arms and legs. The Katsinam they represent cannot be clearly identified. They are 10¾ inches and 6½ inches high and are in the Arizona State Museum collection.

cylindrical bodies and fully carved heads. Finally, when a girl reaches the age of two years or so, she receives a figure with a fully carved head and body, representing the final stage of postnatal development. These are what the Hopi call *tithu* and non-Hopis generally refer to as kachina dolls.

Barton Wright, who is internationally known for his research on kachina dolls, identifies four stylistic periods in the development of the tithu: the Early Traditional tithu, dating from 1850 to about 1910; the Late Traditional tithu, from 1910 to about 1930; the Early Action tithu, from 1930 to about 1945; and the Late Action tithu, from 1945 to the present. The last period shows many variations, including the very large dolls of the 1960s and 1970s, some reproduced in porcelain or cast in bronze or silver.

Starting in the early to mid 1970s, some carvers

began to carve so-called kachina sculptures, which
are common today. In 1978 dolls appeared that were
only partially painted and that were stained in the un-
painted areas. Barton Wright calls these dolls muted,
because colors are only sparingly used. Such dolls
have become very popular among carvers and collec-
tors in the last decade.

The Early Traditional Style

Early Traditional kachina dolls are generally
carved from one piece of cottonwood root. Pieces of
the face—the mouthpiece, ears, or horns, for exam-
ple—may be glued on and real feathers added at the
top of the head. Their appearance is stylized in form

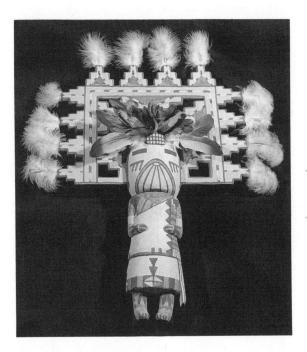

*Palhikwmana, a Butterfly Kat-
sina Maiden doll carved by
Manfred Susunkewa. This mod-
ern re-creation of the Early
Traditional style of tihu shows the
use of vegetable dyes, mineral
pigments, and feathers from
nonendangered bird species. The
figure won a first prize at the
Hopi Artists Exhibition at the
Museum of Northern Arizona on
July 4, 1990.*

and decoration. No larger than eight or at most ten inches, their bodies only approximate human proportions. The arms, usually at right angles, are pressed against the body. A static kilt and sash mark the lower part of the body, often only painted on, and the legs are much too short. The head, however, is carved and painted correctly to identify clearly the Katsina that the doll represents. The surface is often rough, because after the carving was finished it was smoothed only with a stone. Mineral and vegetable pigments were used for painting, with a wash of thinned white clay underneath to close the pores of the wood.

When freshly painted, these dolls must have looked colorful in their bright pastel hues. Most of the detailed painting was lavished on the head, while the rest of the body received only rudimentary painted-on clothing and body painting. Unfortunately, these colors are very fugitive and are not resistant to water; they peel off easily after handling and over time. Yet with all these technical shortcomings, they exhibit a pronounced spirituality because of their strong stylization and abstract rendering.

Some early dolls have more realistic body proportions and longer legs carved from one piece of wood. These are the so-called split-leg dolls. Some of these are carved to indicate the gender of the Katsina they represent. The body is painted all over to simulate flesh tones, but bright colors are used only in a few areas. Some portray limited body movement.

With more white people visiting and moving to the Southwest in the late nineteenth century, interest in kachina dolls grew, and the demand from non-Hopi people stimulated the increase in carving and with it the increase in technical skill. The demand for dolls for nonreligious purposes started to change the style of

the tihu. Outsiders, less interested in spiritual meaning than in aesthetic appearance, may have encouraged carvers to incorporate better body proportions and less stylization into their work. By about 1900 the figures of the tihu were a more naturalistic representation of the human body, and the surface treatment saw alterations in technique. Traders had come to the Southwest in the 1880s and had brought commercial goods to the Hopi area, making newer tools available, including commercial paints. Slowly the mineral and vegetable pigments fell into disuse in favor of commercial paints. Dolls were more finely carved but were still stiff and static. They increased to about ten to twelve inches in height. A photograph from 1902 shows a doll that must be at least two feet tall, hanging on a wall with its arms and legs in active motion. Barton Wright considers this the first Action Doll. Apparently Hopi carvers occasionally carved kachina dolls in agitated action long before this style became popular. But when one observes tithu in museum collections and in period photographs, it becomes clear that most dolls were still represented quite stiffly and were definitely meant to be hung on a wall, for their backs are flat and unadorned, and their feet lack a base.

The Late Traditional Style

According to Barton Wright, the Late Traditional tithu, carved between 1910 and 1930, incorporated only subtle changes toward more realism. Around the turn of the century, scientific expeditions to the Hopi country had gathered, extensively researched, and documented large collections of Hopi cultural material for eastern institutions. Alexander M. Stephen was

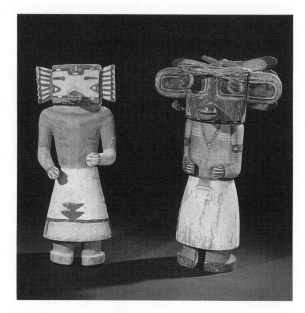

The Late Traditional style tihu still has a stylized body, but the body proportions are better and the arms show some movement, though the feet are still solidly on the ground. More detail is depicted in carving and painting. The Qa'ökatsina (Corn) kachina doll on the left dates from 1920 and stands 10½ inches high. The Hoololo tihu on the right was carved sometime before 1920 and is 11½ inches high. Both are in the Arizona State Museum collection.

one of the early anthropologists studying the Hopi, as was Jesse Walter Fewkes, the leader of the Second Hemenway Expedition. Fewkes collected extensively for the Peabody Museum of Harvard University. Private collectors like Thomas Keam and H. R. Voth gained the trust of the Hopi, and it is said that each of them had more than a thousand tithu. After a time, Hopi elders began to voice their opposition to the collection of their religious objects, especially during a time when the federal government and various missionaries were making great efforts to destroy Hopi culture by discouraging plaza dances and other religious ceremonies. As a result, the Hopi refused to give any religious information to outsiders, and the production of kachina dolls declined.

Dolls from this period still have a stiff stance, with both feet firmly on the ground. Their legs are still short, and generally their arms still hug the body. Most

of the costumes and decorations are painted with tempera colors, and occasionally cloth fabrics, leather, and feathers are used.

Many Hopi resented the sale of kachina dolls, and many still do today. Yet Hopi men needed money to provide for their families. It became even more difficult to raise enough food when their land was rapidly being taken away from them by Navajos and whites. Surrounded by a cash economy, they were forced to change their noncash trading habits. Tewaquaptewa, the chief of Oraibi, found a way to avoid violating the taboo of selling true kachina dolls. He was a good carver and sold his dolls to white people between 1910 and 1930. His dolls, however, are not accurate replicas of Katsinam. He made deliberate alterations and added his own innovations to avoid offending the spirits.

The Early Action Style

In 1933 the federal government appointed John Collier to be the commissioner of Indian affairs. He reversed the destructive policy of government regulation and gave the Indians back their religious freedom. This action produced a renewed interest in the production of religious paraphernalia, including kachina dolls. Barton Wright points out that experiments with unpainted wooden figurines date back to the 1930s. This was encouraged by Harold S. Colton, the founder and director of the Museum of Northern Arizona in Flagstaff, who asked a Hopi then employed at the museum to carve two figures—neither of them kachina dolls—and leave them unpainted. The carver, Jimmie Kewanwytewa, apparently felt very uneasy

about leaving these figures unfinished. The procedure deviated too much from tradition and it was not repeated until the early 1960s.

In the late 1920s and 1930s arms came to be separated from the body, though the feet still rested securely on the ground. By 1950 the feet too became restless; the knees were more often bent, and here and there a foot was lifted. The Action Doll had arrived, and the pace of development in motion and surface decoration quickened.

These changes in form were partly influenced by traders and collectors, who demanded greater realism so that Hopi men were challenged to adapt their carving skills accordingly. Many carvers now found it difficult to carve extended arms from the same piece of wood as the body. They solved this problem by carving the arms separately and attaching them with nails and glue. Often the same was done with the legs. Protrud-

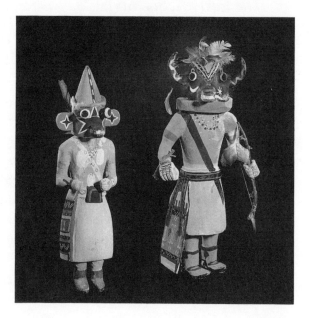

The Early Action style tihu has more realistic arms and legs, and the head is sometimes turned slightly. Overall, the action is still limited, the appearance static and stately. Commercial and poster paints provide the color. The Pöögangw (Older of Twin War Gods) kachina doll on the left is almost 12 inches high. The Hoote tihu on the right dates from 1940 and is 13½ inches high. Both are in the Arizona State Museum collection.

ing pieces of the face had always been carved separately and glued on. The joined areas were made invisible with wood filler, undercoat paint, and tempera or poster paint. In addition, it became very popular to use more organic materials for the costumes. What in prior years had been seen only from time to time became common practice: kachina dolls were "dressed" in real clothing. Fabric was used for capes and kilts, leather for bandoliers and moccasins, and commercial yarn for garments. Hobby stores carried tiny metal bells and glass beads to make necklaces, as well as real shells for other head and body decorations. Fir and juniper twigs formed neck ruffs but were soon found to dry out too quickly, making a doll look unattractive. They were replaced by plastic greenery and eventually by green yarn cut to look fluffy.

The Late Action Style

The term Late Action style refers to those dolls which display realistic body proportions and movements and which have been produced since about 1945. The surface treatment of these dolls can vary greatly and can include all techniques and materials used in the previous styles. The technique of carving kachina dolls from several pieces of cottonwood root and using organic materials for the costumes is still used today, and such dolls can be found in many Indian arts and crafts stores. Carving pieces separately is also an economical way of using smaller pieces of wood, thus stretching the cottonwood supply a carver has available.

In the early 1960s, when Action Dolls became

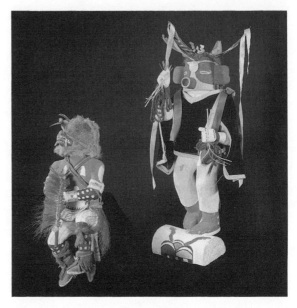

In the Late Action style tihu, from the 1950s the body proportions and actions are more realistic, and the costumes are more detailed. The Kwewu (Wolf) kachina doll at left is adorned with real fur, leather, and horsehair. It is 8½ inches high. The Tsorposyaqahöntaqa (Turquoise Hanging Over the Nose) kachina doll at right has a real velvet shirt and is decorated with ribbons and wool. It stands 13½ inches high. Both are in the Arizona State Museum collection.

popular, two young Hopi men began to represent the human body in anatomically correct proportions and musculature, and they had great influence on the following generation of carvers. Alvin James Makya, originally from Bacavi on Third Mesa, and Wilfred Tewawina, from Shungopovi on Second Mesa, today live in Tuba City. Their carving skills were well known in the early 1960s, when they carved kachina dolls and secular figures. Responding to a request from a white collector, for example, Alvin carved a nude figure called *Princess,* which was subsequently featured in a 1964 issue of *Arizona Highways.*

Several of the younger carvers who are famous today acknowledge their debt to Alvin James Makya in particular. They saw his figurines when they were young and were strongly inspired by them. Von Monongya, a nephew of Alvin, was influenced to strive for the same anatomical realism, as were Arthur

Holmes, Lowell Talashoma, and Orin Poley, who was
born in Bacavi and as a youth observed Alvin carving.
Wilfred Tewawina was a similar inspiration to his
nephew Cecil Calnimptewa, Jr., an excellent carver.
Cecil himself is admired by other carvers and has
become a very good teacher who advises his relatives
in Moenkopi and his late wife's brothers in the Keams
Canyon area. Cecil has worked with his cousin Dennis
Tewa in Moenkopi and frequently shares his time with
his brothers-in-law Alvin and Wallace Navasie and
John Kootswatewa, all from Antelope Mesa. Dennis
Tewa, one of the most acclaimed modern carvers, in
turn influenced his brother-in-law Loren Phillips and
has been an inspiration to his brother Ros George. Two
other carvers in Moenkopi, Jimmie Gail Honanie and
his brother Aaron, are now working with Loren Phil-
lips, and their skill is steadily improving.

Contemporary Hopi carvers expand their cre-
ative talents into all forms of tihu. Recently some have
stretched the definition of a kachina doll. Their wood
carvings are more abstract but incorporate Katsina
elements. These carvings are generally called kachina
sculptures to differentiate them from kachina dolls.
The heads and upper bodies of these sculptures are
portrayed like Katsinam and are correct in detail and
color, but the arms and legs are usually omitted. Often
these sculptures incorporate symbolic designs and
motifs like ears of corn, plants, or pueblo scenes.
Almost all of them are stained and show the pigments
of the six directional colors in selected areas. Such a
carving takes less wood and less time to carve and
is therefore preferred by young carvers who have less
access to wood and need cash quickly. However, artists
like Jim Fred, Orin Poley, John Fredericks, Delbridge

Honanie, and Neil David find greater artistic freedom in carving sculptures. In them they can express their own spiritual feelings to a greater extent than within the confines of religious restrictions imposed by carving kachina dolls.

The Artist Hopid group may have influenced the creation and spreading of sculptures. Artist Hopid was formed in 1972 by Michael Kabotie, Terrence Talas-wayma, and Neil David, later joined by Delbridge Ho-nanie and Milland Lomakema. Collectively they have had a great influence on Hopi artists, in part through their often powerful use of stylized symbolism. All of them are foremost painters, combining abstract forms with those of Hopi religious symbolism. It is natural for artists like Neil David and Delbridge Ho-nanie to translate this combination into their wood carving. By doing so they transform the once exclusively religious art form of the tihu into a new form of wood carving outside the sacred.

New Carving Techniques

The development of kachina-doll carving has seen great changes in the last hundred years, and particularly during the 1980s. Some of the well-known carvers of today, most of them in their thirties and forties, used organic materials for their dolls until 1982. Others never used them and always carved costume details and decorations. Since 1982 the trend toward carving everything has accelerated to the point that even the finest embroidery on a sash or kilt is carved. Most skilled carvers today carve the tiniest and most intricate motif and design elements before a doll is stained or painted. Traditional carving tools have not altogether been discarded, but it is the many new ones that have been added that have made this refinement possible.

If we suppose that kachina dolls date to before the arrival of the Spaniards, we must assume that stone knives were used for carving them. A century ago, kitchen knives and butcher knives were available, and today pocketknives and X-Acto blades. Add to these such new tools as chisels, sandpaper, hand and power saws, the woodburning iron, and the Dremel tool, plus new glues, stains, varnishes, and oil paints and it is no surprise that cottonwood-root carving is constantly being refined. With these tools Hopi artists now

The pocketknife is still the most used carving tool. Here, Loren Phillips is carving the facial features of a So' yok wuuti (One Who Enforces) kachina doll.

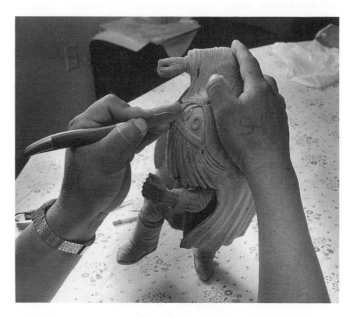

achieve ever-greater realism. This goal leads to experimentation with new products and eventually to innovations in technique.

In the early 1970s Brian Honyouti of Hotevilla experimented extensively with various wood preservatives and varnishes. He mixed his own varnishes to find the kind he liked best. He preferred varnished wood rather than painted surfaces and decided to leave the areas that represent skin, buckskin, and the white cotton of a kilt unpainted. He added color only where the directional colors were needed on heads and costumes. These dolls were still considered to be kachina dolls, but they had a new appearance due to their refined surface technique. Unpainted figurines had been rejected or had gone unnoticed ten years earlier, but now carvers liked Brian's innovation and readily copied it. Today this so-called stained technique is widespread, even though in most cases only wood

preservers are used. Some carvers, however, mix in a pigment and thus create a true stain, and acrylics can be painted over an oil-based stain provided that it has thoroughly dried. Another innovation resulted from Brian's experiments in 1978, when he decided to use oil paints instead of acrylics.

Initially, dealers and collectors resented this "radical" shift, but Brian continued to use it, and other carvers picked up his idea. Now the art market not only tolerates but encourages his technique. Of course, oil paints take much longer to dry than acrylics, but they have the advantage of adhering better to the oil-based varnish, especially over those acrylic colors that have been thinned down with water. Brian and his

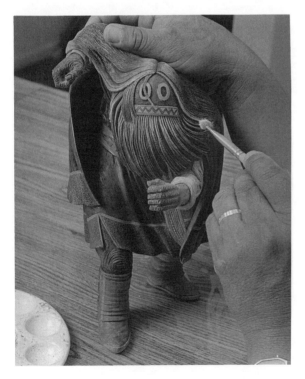

After applying a coat of stain colored with pigments and filling specific areas with oil paints, Loren Phillips takes his representation of realism one step further by using oil paints to add color highlights to the strands of hair, the beard, and the wrinkles in the clothing. Note that he carves wrinkled hands and knees to simulate an old Katsina dancing.

brother Ron like to thin their oil paints to achieve more muted tones. Still, the technique of using acrylics over a varnish or stain is the favored method of most carvers who produce "muted" dolls.

Modern artistry in carving is displayed in these examples created by Ron Honyouti in 1988. The dolls range in size from five to sixteen inches. They depict, from left, a Sakwapmana (Blue Corn Maiden), a Sakwatsmana, a Mongwu (Horned Owl), and an Angaktsina (Longhair). The Angaktsina is bringing harvested corn and a watermelon into the dance plaza.

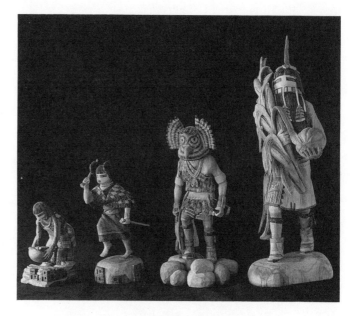

Experiments go on to speed up the carving process and simplify the painting technique. Since 1982 several carvers have used oil paints for the accentuating colors (the colors associated with the six cardinal directions), mixing them with turpentine, paint thinner, or mineral spirits. Each artist has his or her own formula. One carver uses acrylics and oils freely on the same doll, preferring acrylics for the more intense colors. The result is indistinguishable to the eye. In 1987 Dennis Tewa introduced a West German oil paint that other carvers and he have come to favor. It can be mixed with water, it dries fast, and it adheres well to stain-treated wood.

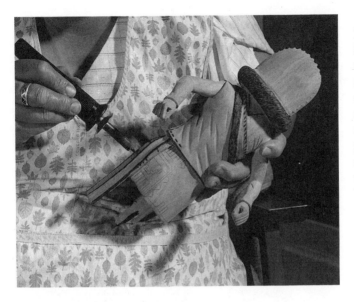

The woodburning iron has become a popular tool to create the textures of spruce, cordage, and hair, and also the details of embroidery and woven patterns. Here Geraldine Youvella is using it in her work on a Wuuyo kachina doll.

Hopi artists like to experiment with whatever new tools and materials the market has to offer, and they constantly find ways to improve their techniques and skills. This is certainly true of Von Monongya, who in 1982 adapted the electric woodburning iron for kachina-doll carving and who remains the master of this tool. In his hands it produces the finest strands of hair on Longhair kachina dolls and Katsinmamant (Katsina Maiden) dolls one can imagine. The woodburning iron makes it possible to enhance the fine details in clothing, to indicate knuckles and wrinkles on hands, and most of all to give carved feathers a downy-light appearance by incising numerous tiny lines into them. This tool has sped up hand carving considerably and is used today by many carvers.

By the mid-1980s another electric tool had made its impact on the refinement of kachina-doll carving. The first carver to use the Dremel tool cannot be discerned; it may have been Cecil Calnimptewa, Jr., who

Another tool employed to represent certain textures realistically is the Dremel tool. In the hands of a skillful carver and with the appropriate bit, this tool can produce a texture that accurately simulates animal fur.

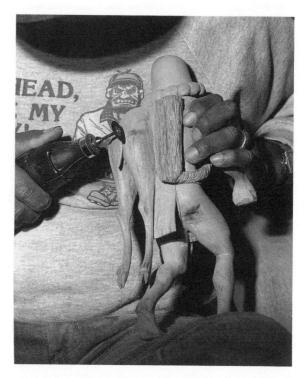

uses this tool to its full potential, searching out new bits that he uses to create a great variety of textures. His skill in using the tool is impressive and suits his particular style of carving perfectly. Because he is an expert teacher, other carvers will surely improve their own handling of this difficult tool. Several carvers assert that the Dremel tool requires much practice and can even be dangerous because of the speed with which it works on the soft cottonwood root. Some own this tool yet use it very seldom, relying on their trusted pocketknives, files, and chisels instead.

All these power tools are just another step in the development of carving. If they can be used for a specific purpose, carvers believe, why not use them? They

can speed up a process that would otherwise take much longer and require much more energy, which can be put to better use in creating more intricate carvings. More motion and action can now be worked into the figures, and more agitated surfaces and detailed textures can be created. When the techniques are easier to apply, the artists have access to a greater range of possibilities and more time to express their feelings in their carvings.

Such techniques have supported the emphasis on ever greater realism in kachina-doll carving. The illusion of movement was carried further in the decade of the 1980s than in the century that preceded it. Musculature and correct proportions have been perfected by

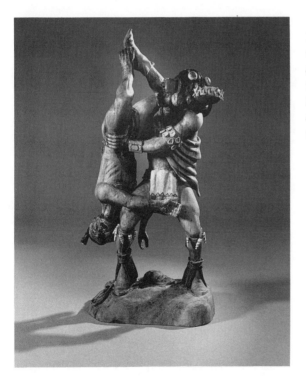

This Nata' aska kachina doll, not quite finished, shows the complexity of a two-figure carving by Cecil Calnimptewa. It also reveals his realistic rendering of the human body in motion.

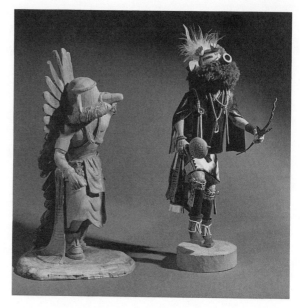

Cecil Calnimptewa's carving style changed dramatically in the 1980s. On the right is a Naavantaqa (Velvet Shirt) kachina doll he carved in 1979. It is dressed in real velvet, and it has a neck ruff of green yarn, chicken feathers on its head, and real beads for a necklace. The hands show painted-on wrinkles, and real cordage and ribbons adorn the shirt, wrists, and knees. The base was carved separately. On the left is an unfinished Hoote kachina doll Cecil carved in 1988. The neck ruff, wristband, cordage, and bead necklace are carved directly into the wood. Natural folds in the kilt and sash enhance the sense of reality. But most of all Cecil's great progress toward expressionistic realism is seen in the solidity of the body, which has a natural stance and motion and greatly enhanced musculature in the arms, legs, and upper body. The base is an integral part of the figure.

several carvers to the point that their carvings can rightly be called sculptures. Fingers, veins, hair, yarn cordage, embroidery, spruce needles, and intricately detailed and shaded feathers are all carved by hand. The bases the dolls stand on are incorporated into the figure. Most are carved from the same piece of wood as the figure, and often they are adorned with related motifs or symbols. Portions of the body are left unpainted and are instead stained with a varnish to let the grain of the wood show through, adding a new dimension and texture to the surface of the figurine. The all-important colors of the face are retained, as are the colors in other areas where green, red, yellow, white, and black are required by tradition, but overall these kachina dolls have a much more refined appearance than those created with earlier techniques. The last decade has seen a great increase in the production

of "muted" dolls, and the finest of these are the dolls most collectors are interested in today.

The trend toward greater realism has affected most carvers, including those who carve only for ceremonies. Carvers who still carve in the Early Action style have become rare. But alongside this modern trend, a multitude of different kachina dolls are being made by Hopi carvers today, all of them variations on the four major styles used in the past. By tradition, the same Katsinam are represented. The increasing changes are coming in the refinement of surface treatment.

Modern Hopi Carving

This section is intended to give the reader some appreciation of the work involved in creating a kachina doll. Most carvers need at least two to three weeks to complete a carving, because none of them can work eight hours every day on a single piece. Because of this, it proved very difficult to find a carver who was able to set aside four days of continuous work to provide the basis of observation for this section.

Von Monongya was able and willing to work under these conditions for a period in 1987, but my own time limitations made it necessary to him to choose a figure that could be completed in a short time but which incorporated essentially all the steps in his meticulous carving technique. Von settled on a Sa'lakwmana sculpture, as this eliminated the need to devote a considerable time to carving arms and legs, and the carving techniques he would use would be the same as for a kachina doll. To save time, he roughed out the shape of the figure before my arrival. Yet, with all this planning, he was unable to carve and paint the figure's tablita while I was there. Instead, he completed the work later and had the sculpture returned from the art gallery in New York City where it was on exhibit so that I could photograph the finished work

for this book. As a result, I have been able to present here a representative Hopi carving from the point when it was a roughly shaped block of cottonwood root to its beautiful finished form.

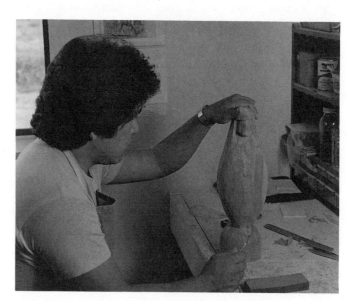

After shaping the piece of cottonwood root into the rough form of a Sa' lakwmana sculpture, Von Monongya contemplates how to proceed.

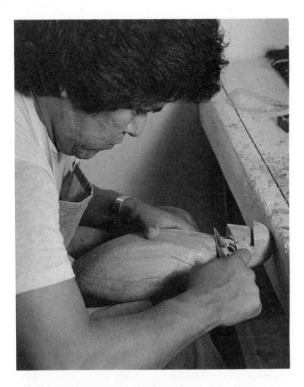

Using his pocketknife, Von shaves off thin layers of wood toward the neck of the sculpture.

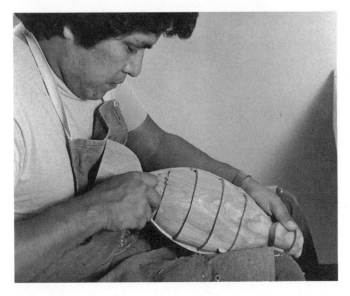

The front of a Sa'lakwmana costume consists of overlapping rows of feathers. To reproduce them in wood, Von first divides the front of the sculpture into five distinctive segments.

Then each division is vertically segmented into sections that will represent feathers. This step is executed with an X-Acto knife because of the deep and precise carving it allows.

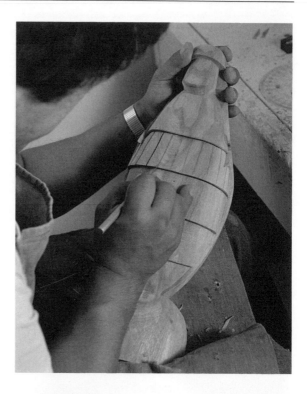

Each vertical section now begins to take on the shape of a feather. Von uses a chisel to give the upper surface of each feather a rounded look. Then the tip is clipped off at the corners and undercut to give it a realistic appearance.

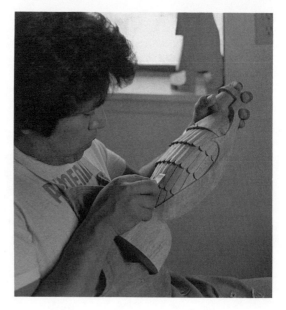

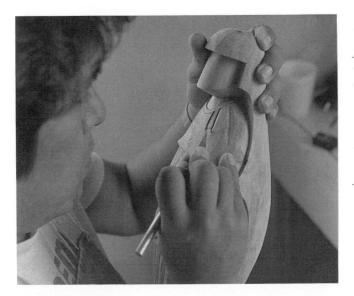

Von next carves the fine details of the turquoise necklace that decorates the neck of the Sa' lakwmana. For this fine detailing, in which every bead is carved, the X-Acto knife is again the preferred carving tool.

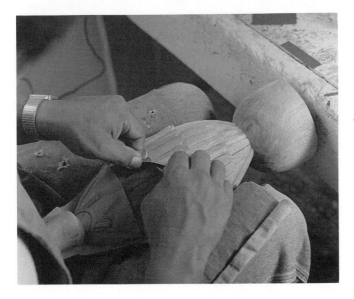

One of the most important, and most tedious, operations in creating a kachina doll is sanding the carved sections. A good carver strives for a satiny finish on the wood, and producing it is a very time-consuming process.

The final detail of creating the barbs on each feather is achieved with the woodburning iron. The iron creates the fine incised lines that simulate the soft, feathery quality, and at the same time it colors the wood in a desirable brown tone that further helps to give it the semblance of real feathers. Von was the first carver to apply the woodburning technique to kachina-doll carving.

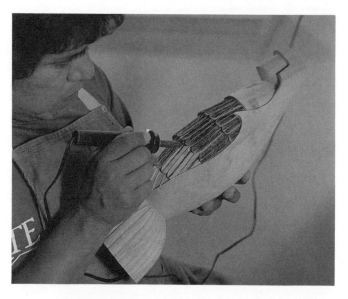

To close the pores of the wood and prepare the surface for painting, a wood preserver is applied next. In this case it is a semigloss Delft wood finish. Besides preserving the surface, this gives the figure a more finished look, and most important, it enhances the grain of the wood, a feature preferred today by carvers and collectors alike.

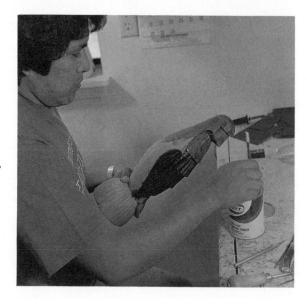

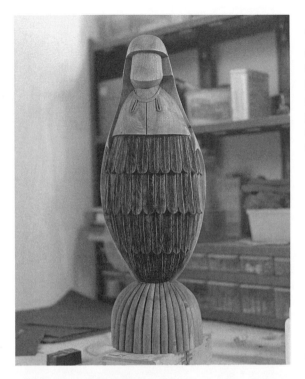

The sculpture at this stage of completion reveals the carver's excellent carving technique. The smooth, elegant, yet strong lines of contour enhanced by the simplicity of form give the carving an appealing modern and spiritual effect.

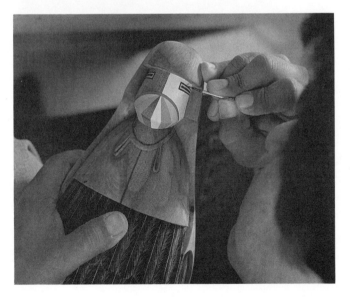

Von next applies colors to the face and head-dress in accordance with the colors of the Katsina represented. Von uses a commercial watercolor brush with either acrylic or oil paints.

The finished carving is a wood sculpture worthy of the acclaim it received at a show in a New York art gallery in 1986.

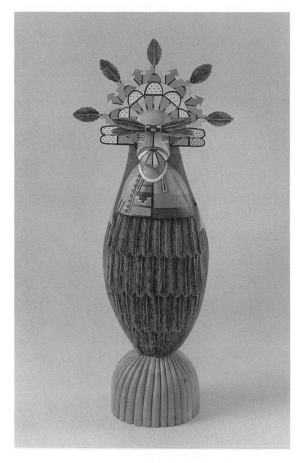

The Carver as Artist

At the turn of the century, when kachina dolls were
collected in great numbers, carvers were most likely
compensated for their artistic endeavors, and what was
once an art form created solely for ceremonial pur-
poses and in anonymity changed considerably when it
entered the system of monetary exchange. With this
change the object left the ceremonial realm and was
now intended to be displayed in museums or to deco-
rate private homes. The maker of a kachina doll was
no longer necessarily anonymous. He was known to
the buyer, who may have recorded his name and the
date of manufacture, and who might come back to the
same carver for subsequent purchases. Some of the
kachina-doll makers were more prolific than others
and carved in a manner that was particularly pleasing
to the buyer so that more dolls were collected or pur-
chased from him than from other carvers. The per-
sonal preference of the buyer was influential in making
a certain carver known. Then as now, the influence of
the market on an art form was reflected in concessions
to that market's taste.

With the emergence of individual artists who
were recognized by dealers and collectors, dolls with
the signatures of their makers became more numerous.
Barton Wright believes that Jimmy Kewanwytewa,

Delbridge Honanie sells his dolls and demonstrates his carving techniques at the Heard Museum's Indian Fair in 1988. He is one of the carvers who also creates the type of putstihu taywa'yta dolls shown here, which have fully carved heads but only rudimentary arms painted on the body and no legs. These dolls have feathers of nonendangered bird species.

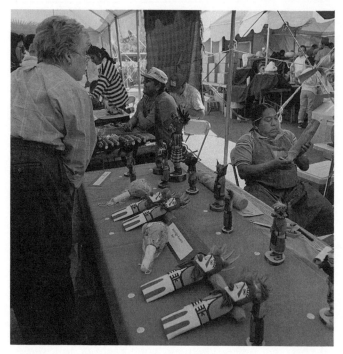

who worked at the Museum of Northern Arizona in the 1930s and who signed one of his initials under each foot of his dolls, was the first carver thus to identify his work. But since most dolls not meant for a ceremonial function have bases, the carver's signature could be added without interfering with the representation of the katsina. Today almost all dolls meant for sale are identified with their maker's name and often with the artist's clan symbol as well. However, only dolls for sale are thus tied to their makers. All dolls carved for ceremonial purposes are unsigned and are recognized as having been made by katsinam, as prescribed by tradition.

Usually when an ethnic art form becomes a fine art, it is the aesthetic values of collectors and gallery

owners that prompt this change. Such parties are instrumental in the success of certain styles, trends, and even artists. If one artist's work is in greater demand than another's, then that artist can demand a higher price. The aesthetic value created by collectors and connoisseurs usually translates into a parallel financial value.

In the case of kachina dolls, the trader of Indian arts and crafts usually brings the artist and the collector together. The trader often maintains a store on or near the reservation where Indian artists can bring their creations for sale. Until recently the role of Indian traders, most of them whites, has been of fundamental importance. Observant and sensitive traders have had an enormous influence on the development of young artists and their art. They have also provided the immediate cash so dearly needed by most artists. One of them, Ferron McGee, Sr., the now-retired

Today, after completing a doll meant for sale, the artist signs his name on its base. In this case, Tino Youvella also includes his clan symbol.

Bruce and Ron McGee own McGee's Indian Art Gallery. The McGee family has been in the trading business in the Navajo and Hopi region for two generations and has been very influential in helping many Indian artists to become established in the art and known to collectors.

owner of McGee's Indian Art Gallery, started a family tradition of encouraging Indian artists—among them many Hopi kachina-doll carvers—in their endeavors.

The Hopi carvers with whom I made contact speak of Ferron's son Bruce respectfully and gratefully. He has been the manager of McGee's Indian Art Gallery (earlier called Keams Canyon Arts and Crafts) since 1972 and has helped many fledgling carvers by buying their first kachina dolls and encouraging them to continue in their efforts. Bruce recognizes works of particular merit and enters them in juried shows, either at the Annual Indian Intertribal Ceremonial in Gallup, New Mexico, or the Annual Indian Market in Santa Fe, sponsored by the Southwest Association on Indian Affairs. In almost all these cases, the pieces win prizes and the career of the artists is launched. An amazing number of carvers readily admit that they are indebted to Bruce for their first promotion or sale.

Many artists carve only in response to orders
from collectors, who approach the artist directly or
ask Bruce to be the go-between. Others carve without
orders, knowing that Bruce or another merchant will
buy their work. Those stores closest to the Hopi Reser-
vation buy most of their kachina dolls directly from
the carvers who make them.

Dan Garland, who owns a gallery in Sedona,
Arizona, is a well-known trader on the west side of
the reservation. Dan has had a major influence on the
cash flow of certain carvers, mostly those living in
the Flagstaff and Tuba City areas. Other dealers and
owners of Indian art stores and galleries come from as
far away as Albuquerque and Santa Fe, southern Cali-
fornia, Colorado, and, of course, Phoenix and Tucson.
Dealers from these areas periodically travel to the Hopi
Reservation to collect dolls from those carvers they
know best or from stores on the reservation.

*Dan Garland, owner of
the Garland Gallery
in Sedona, is shown
here with some excel-
lent examples of ka-
china dolls by Lowell
Talashoma and other
carvers. Dan is a very
important link between
artists and collectors.*

In recent years some Hopi entrepreneurs have opened their own art stores, providing Hopi artists with another outlet for their work. Such stores are found at the foot of Second Mesa on Highway 264, at the Hopi Cultural Center on Second Mesa, in Kykotsmovi, and in Oraibi. The Monongya Gallery in Oraibi is owned and operated by Von Monongya, an excellent kachina-doll carver who also buys and sells the dolls of other carvers. Cecil Calnimptewa, another exceptional carver, opened a store nearby in 1990.

Galleries often arrange shows, usually in Scottsdale, Sedona, Santa Fe, and Albuquerque. Lee Cohen, the owner of Gallery 10 in Scottsdale and Santa Fe, has promoted several of the now-famous carvers, and Gallery Santa Fe East represents Dennis Tewa. Other carvers, like the Honyouti brothers, work mostly through the Adobe Gallery in Albuquerque.

In addition, either the artists themselves or deal-

In addition to becoming a well-known carver, Von Monongya has established himself as a very successful businessman on the Hopi Reservation. He built his own arts and crafts store in Oraibi, where he sells the creations of many Indian artists. With Von are his sales staff, Mae Sekakuku on the left and Marlinda Velasco in the back.

Lee Cohen, the owner of Gallery 10, holds a So' yok wuuti (One Who Enforces) kachina doll carved by Loren Phillips. Cohen features Loren Phillips's carvings in both his galleries, though he shows the work of other artists as well.

ers enter exquisitely carved dolls in juried shows at annual Indian markets. Here they are seen and judged by experts in the field. The Annual Indian Market in Santa Fe is perhaps the most coveted juried show. Many carvers work toward its August deadline for months in advance. Their skills are put into action to produce the very best creations for this annual event. The carvers enter other juried shows and competitions as well, trying to win prizes and thus to enhance their reputations as artists. The Hopi Artists Exhibition at the Museum of Northern Arizona in Flagstaff, held on the Fourth of July weekend, the Hopi Fair in Sedona, and the Annual Intertribal Indian Ceremonial in Gallup are the competitions frequented by most Hopi kachina-doll carvers. Taken together, these determined efforts to achieve the highest quality prove the importance of the competitions in promoting the continued advance of excellence in carving techniques.

The Annual Indian Market in Santa Fe is one of the most important juried exhibitions for the Hopi artists. The scenes shown here are from the 1988 market. At right is a table filled with kachina dolls in the judging room. Cecil Calnimptewa's carving of Nata' aska upending a clown (below) won a first prize and an award as the best carving in the kachina doll division. Besides the official exhibition, local art galleries have special shows of featured artists' works. In 1988 Gallery Santa Fe East celebrated the event with a show of kachina dolls by Dennis Tewa, who is shown on the opposite page explaining his art to patrons of the gallery.

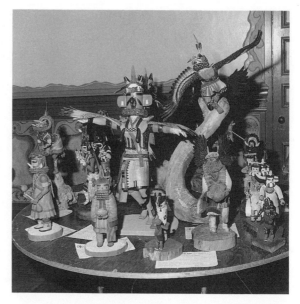

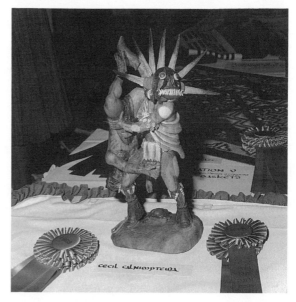

During the summer months, when carvers pre-
pare for these two important juried shows, their
income from the sale of dolls declines. To create a doll
of exceptional quality, a carver needs more time than
usual, quite often weeks or months, depending on
other obligations the carver has to fields or livestock.
Fortunately for the farmers among them, the time falls
during the growing season, when fields and crops
demand less attention than during planting or harvest-
ing. Those men who have to take care of cattle and
horses have greater difficulty in devoting adequate
time to prepare for and compete in shows. In some
families it is essential that wives contribute to the fam-
ily income by holding a job.

A few of the carvers are women, who work either
with their husbands or on their own. Traditionally,
Hopi women do not carve kachina dolls. Instead, as
the carriers of life, women receive these symbols of

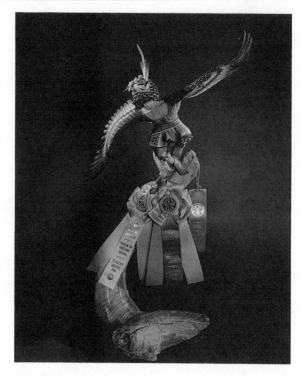

This superb carving of a Kwaa-katsina (Eagle) tihu made by Loren Phillips won a first prize, the Best of Division award, and the highly esteemed honor of Best of Show in the Hopi Artists Exhibition at the Museum of Northern Arizona in 1988.

procreation from the katsinam. But when the possibility of monetary income from the sale of kachina dolls arose, women began to carve them.

According to Barton Wright, the first woman carver to venture into the miniature kachina-doll market was Barbara Drye. Muriel Calnimptewa, who died of pneumonia in 1988 at an early age, was another outstanding carver who regularly won first prizes in Santa Fe in the miniature categories, which include dolls up to about three inches high. She also carved excellent dolls up to ten inches high. Her sister Harriette Navasie Kootswatewa has emerged as Muriel's successor. Miniatures are also carved by men, of course, but the women carvers seem to have a remark-

able skill for fine detail. Miniature dolls are, like very large dolls and those cast in bronze, departures from the regular kachina dolls, which usually range in height from eight to fifteen inches. The miniatures are only produced for the sales market. They are collector's items and are not considered kachina dolls in the true sense.

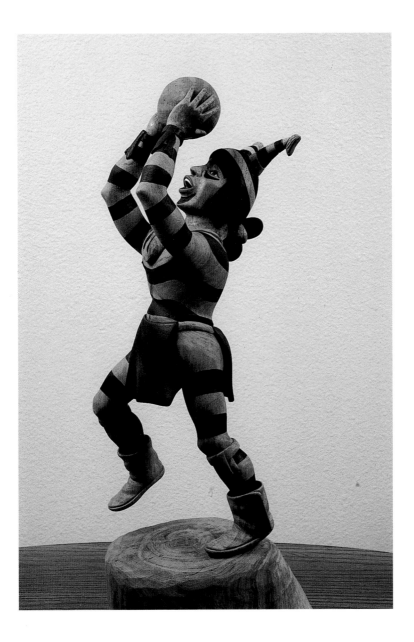

Hano Clown by Alvin James Makya, 1987

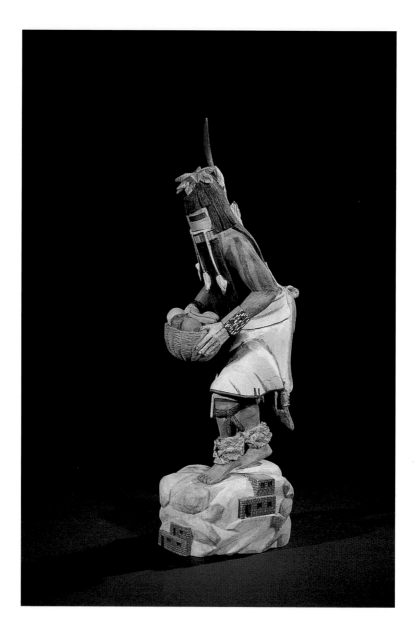

Angaktsina (Longhair) kachina doll by Ronald Honyouti, 1989

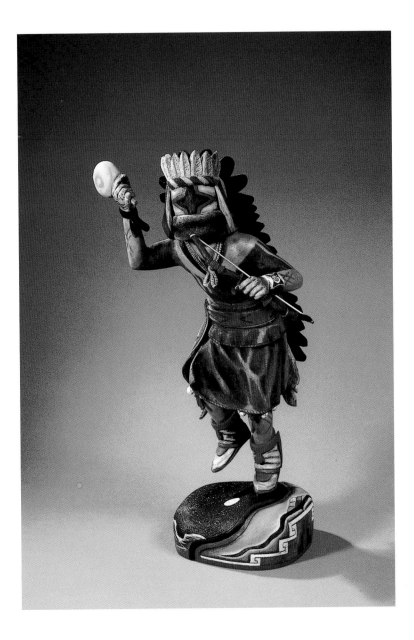

Naangösohu (Chasing Star) kachina doll by Brian Honyouti, 1991

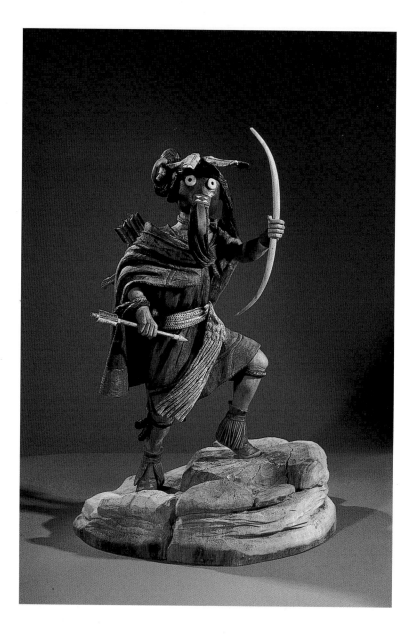

*Tsa'kwaynamuy Siwa'am (Tsa'kwayna's Younger Sister) kachina
doll by Cecil Calnimptewa, 1989*

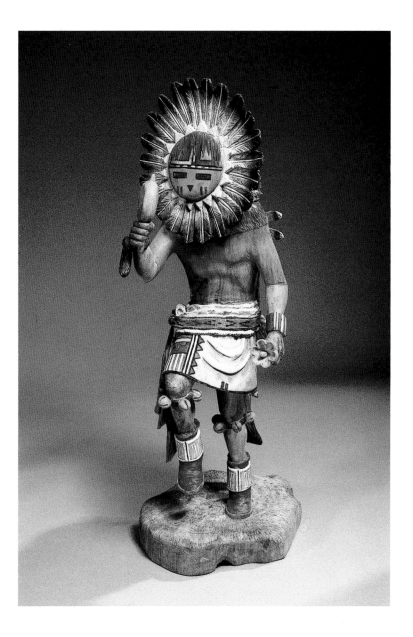

Taawakatsina (Sun) kachina doll by Muriel Calnimptewa, 1988

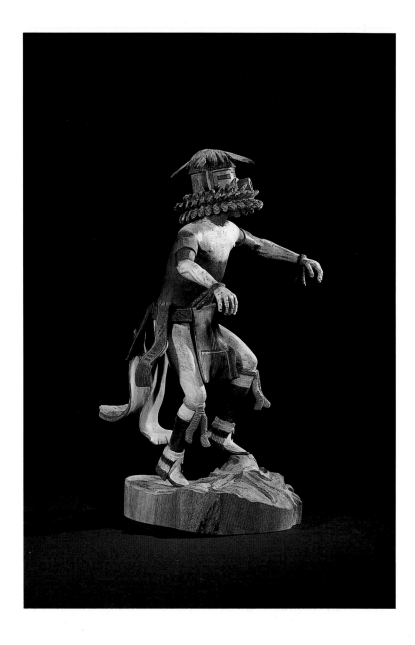

Qa'ökatsina (Corn) kachina doll by Ros George, 1988

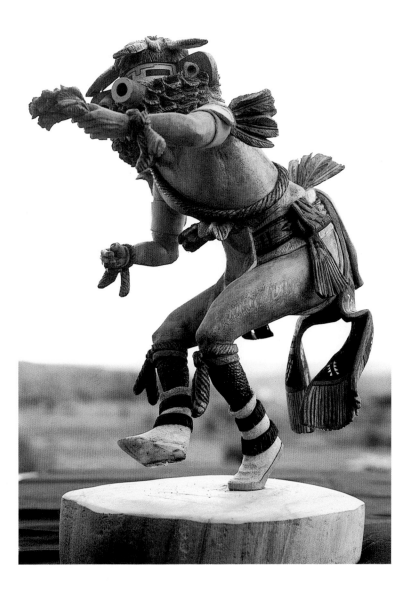

Qa'ökatsina (Corn) kachina doll by Dennis Tewa, 1987

So' yok wuuti (One Who Enforces) kachina doll by Loren Phillips, 1988

Mongwu (Owl) kachina doll by Loren Phillips, 1988

Sa'lakwmana and Sa'lakwtaqa sculpture by Orin Poley, 1988

Hanomana (Tewa Maiden) by Orin Poley, 1988

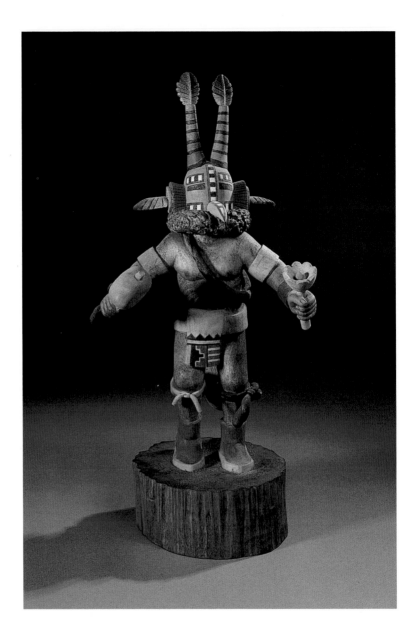

Maahu (Cicada) kachina doll by Jim Fred, 1988

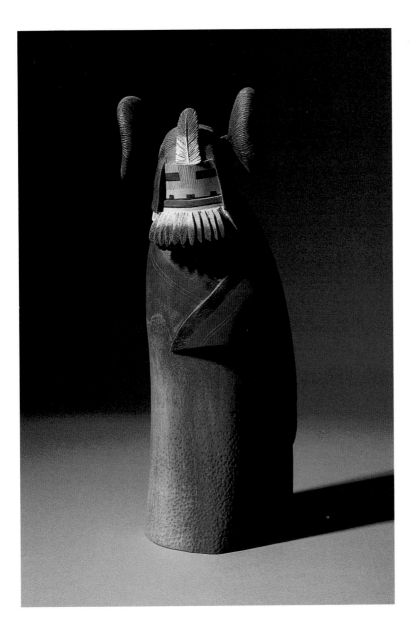

Katsinmana sculpture by Jim Fred, 1988

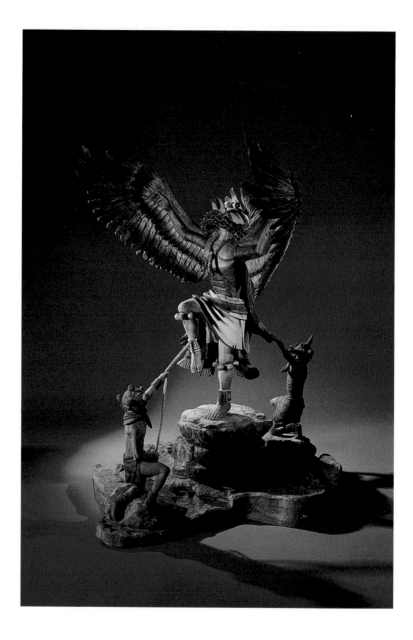

Kwaakatsina (Eagle) kachina doll by Cecil Calnimptewa, 1989

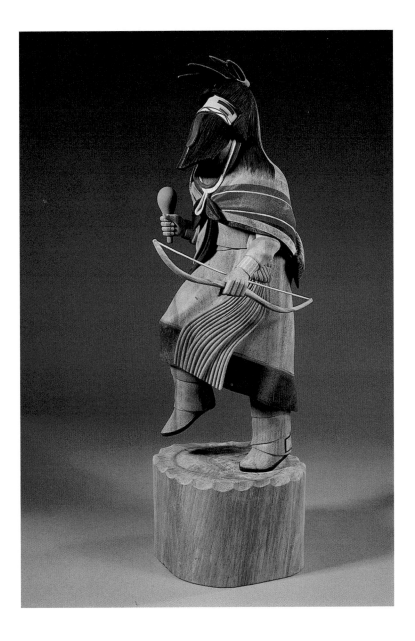

Hewtomana kachina doll by Von Monongya, 1988

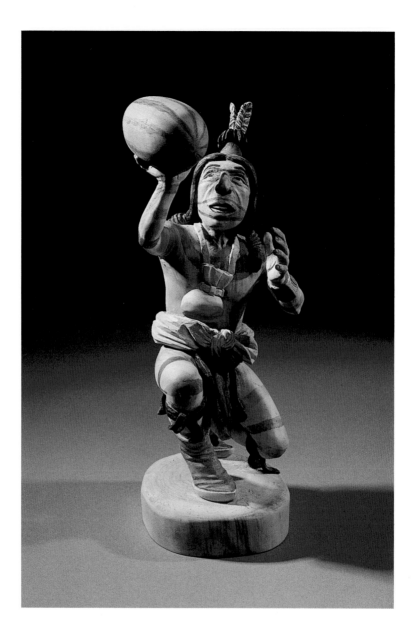

Kaasayle Clown by Lowell Talashoma, 1988

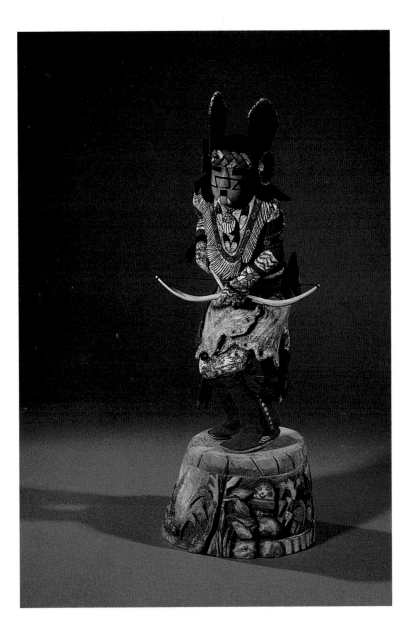

Kòoninkatsina (Havasupai) kachina doll by Neil David, 1990

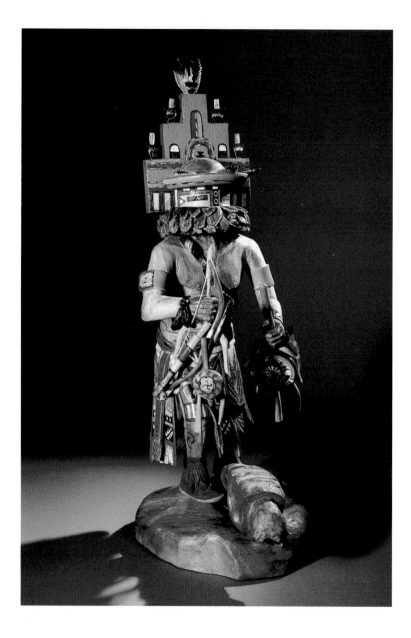

Hemiskatsina kachina doll by Aaron Honanie, 1987

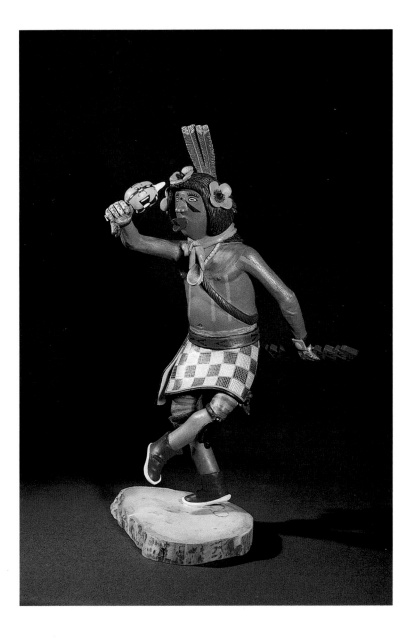

Huuhuwa (Cross-legged) kachina doll by Wilfred Tewawina, 1990

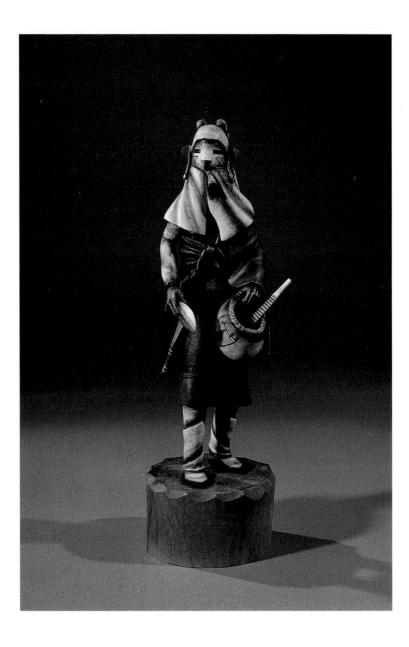

Nuvaktsina (Snow Maiden) kachina doll by Jonathan Day, 1990

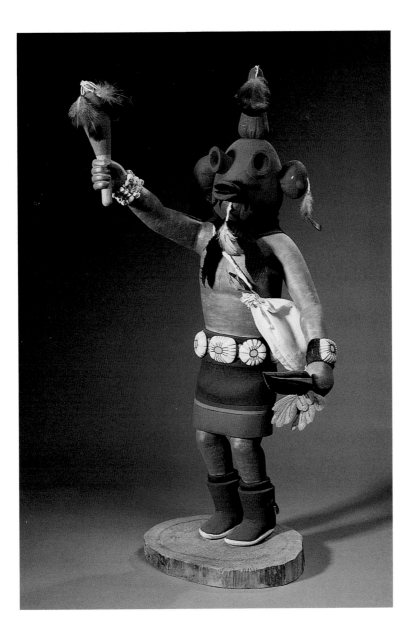

Kooyemsi (Mudhead) kachina doll by Delbridge Honanie, 1988

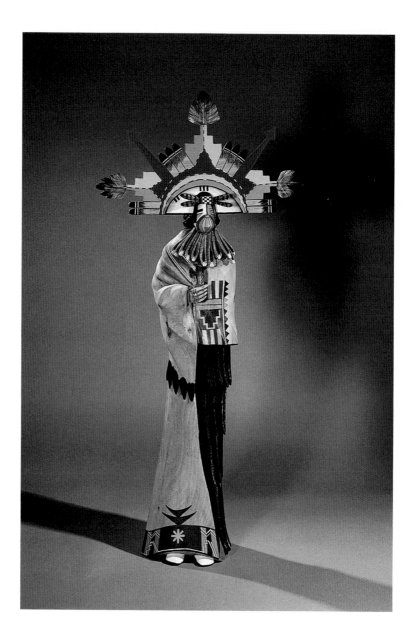

Palhikwmana/Sa'lakwmana combination sculpture by Wilmer Kaye, 1990

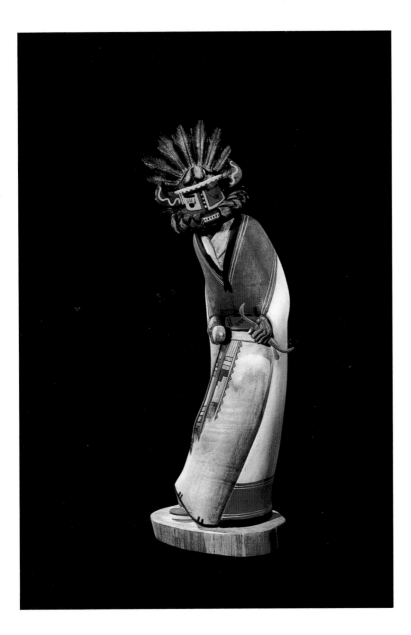

Hotooto sculpture by John Fredericks, 1990

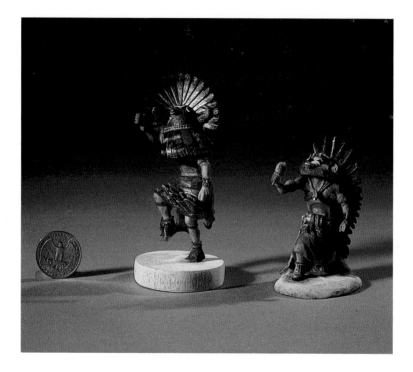

*Wuyaqqötö and Hoote (Broadface and Hoote) miniature kachina
dolls by Muriel Calnimptewa, 1988*

Twenty-Seven Modern Hopi Carvers

The carvers discussed in this chapter constitute only a representative cross-section of the Hopi kachina-doll carvers at work today. They are essentially those carvers I had the opportunity to meet and observe as part of the research for this book and the exhibition that led up to it. Many other Hopi carvers, both men and women, are currently producing very interesting kachina dolls, miniatures, and sculptures in many forms and by a variety of techniques.

Alvin James Makya

Alvin James Makya is the carver who is generally credited with elevating the craftsmanship of kachina-doll carving into an art form. A 1974 *Arizona Highways* article featuring his work established this claim, and it is also based on his art of the early 1960s, when he ventured into a new phase of cottonwood-root carving by creating nude female figures. These, although elongated, had naturalistic body proportions and realistic skin and musculature. Alvin treated them

*Alvin James Makya carving a
Hano Clown figure*

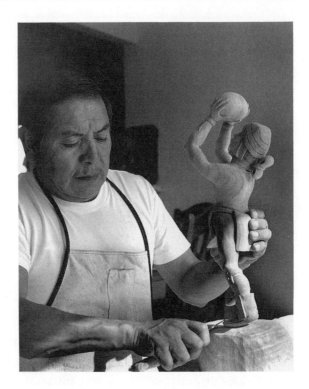

only with a wood preserver and left them unpainted. He says he made them to challenge himself to represent the human body realistically. From then on all his human bodies were rendered in a naturalistic way. He has always carved his dolls from one piece of wood, with only few details attached separately.

Alvin was born in Bacavi, one of the villages on Third Mesa, on May 7, 1936. He lived and raised his family there until 1981, when he moved to Tuba City, where he lives today.

In 1960, after returning from military service, he went to the Hopi Artists Exhibition at the Museum of Northern Arizona in Flagstaff and was inspired by some action dolls he saw. He then started to carve.

From the very beginning, his work was so good that he won a first prize in the Hopi Artists Exhibition in 1961. At that time he was earning his living as a carpenter and could devote only about a third of his time to carving kachina dolls.

Alvin's strength lies in his ability to carve the human body and the human face realistically. His Hano clowns are known for their athletic prowess, often balancing on one foot or holding a large watermelon high above their heads. To be able to carve the facial features, he has to carve the hands that hold the watermelon separately and attach them with dowels later.

In recent years Alvin has been slowed down by diabetes and no longer works as a carpenter. Instead, he carves every day. He sells only to collectors but admits that he cannot make a living solely by carving. When he works he progresses slowly and deliberately, often sitting back and observing the figure before proceeding. All of his kachina dolls and clowns are treated with wood preserver. He uses undiluted acrylic paints sparingly. If a brush stroke is not quite correct, he scrapes the mistake off with an X-Acto blade, sands the area, and applies wood preserver over it. His brushes are commercial watercolor brushes, and his carving tools are X-Acto knives and two modified paring knives.

Wilfred Tewawina

Officially, Wilfred Tewawina was born on January 30, 1929, but his real birth date is not known. He was born in Shungopovi and learned doll carving at the age

of eight, when he was initiated into the Katsina religion. Wilfred moved from Shungopovi to Moenkopi in 1957 when he married a woman from that village. He later moved to Tuba City.

Wilfred is a friend of Alvin James Makya and carved with him in the 1960s. Like Alvin, Wilfred established his name as a carver of realistic body structure in the 1960s. His carvings indicate true body proportions and realistic musculature, and they are an inspiration to young carvers in Moenkopi today, just as they were fifteen and twenty years ago. It can be assumed that his nephew Cecil Calnimptewa, discussed below, was one of those inspired young carvers.

Wilfred's techniques combine the older practices of attaching arms when necessary and painting the whole body in acrylic paints with his own very naturalistic style of carving. He has not adopted the "muted" surface treatment that employs wood preservers in certain areas instead of paint, but his kachina

Wilfred Tewawina carving a kachina doll

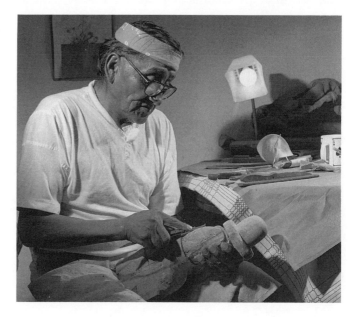

dolls are uniquely active. Most of them are also slightly larger than the average size of eight to fifteen inches; his dolls range from fifteen to seventeen inches tall, and most are carved from a single piece of wood.

Wilfred cannot afford to buy power tools. Instead he uses an ax, chisels, rasps, and knives. This procedure limits the number and type of dolls he can produce. After cutting the rough form of a doll, he continues with a set of knives of different sizes and shapes and a number of files. It usually takes him several days before he can begin sanding and painting. The last step can be done in a day.

He buys his wood from suppliers who bring it from Colorado. The weight of the wood tells him how soft or hard it is. When he carves non-Katsina figures, for which he has to carve faces, he prefers harder wood and uses a sharp little knife for the eyes, nose, and lips.

Wilfred sells his dolls directly to collectors, to the Museum of Northern Arizona in Flagstaff, and to Bruce and Ron McGee. It seems to please him that young carvers watch him work and pick up his way of carving. This is how young Hopi men learn to carve, he says. And his carving style should be an example, because he is an excellent artist who deserves wide recognition.

Brian Honyouti

Brian Honyouti was born to Clyde and Rachel Honyouti on February 3, 1947. He has one older sister and four younger brothers. He lives in Hotevilla with his wife, Rethema, and their two young daughters.

Brian is a man who has never taken the easy path;

*Brian Honyouti working on a
Buffalo Dancer figure*

he is determined to follow his own convictions in his
calling as a teacher and as an artist. He started carving
kachina dolls in the mid-1960s after graduating from
high school. He helped his father paint his dolls and
so picked up basic carving skills. In the late 1960s his
father, who made his dolls no larger than six to eight
inches tall at that time, began to carve his dolls out of
one piece of wood. Brian believes that his father was
the first carver in Hotevilla to do so, because everyone
else was still gluing on arms and legs, as well as other
decorative attributes, onto tithu and decorating them
with real feathers.

In 1968 Brian moved to Tucson to attend the
University of Arizona where he received a bachelor's
degree in anthropology. From 1968 to 1971 he held a

student part-time job at the Arizona State Museum, working with Ernest E. Leavitt, who at the time was curator of exhibits. The museum now has one of Brian's early kachina dolls in its collections.

After Brian's return to Bacavi, he started to experiment with wood preservers and varnishes. He is universally credited with being the first kachina-doll carver to use these as a wood sealer instead of the white undercoat for paint. He tried out all kinds of wood preservers, oil-based varnishes, and linseed oil, mixing them together to produce the varnish he liked best. He would use these on his own and his father's dolls. Brian was also the first carver to substitute wood preserver for paint, leaving areas of flesh tone, buckskin, and cotton unpainted, simply treating them with wood preserver. At that time he was still painting with acrylic paints, but in 1978 he settled on oil paints. Initially, resentful dealers and collectors did not want to buy his dolls, but Bruce McGee provided an outlet for their sale. Ron Honyouti liked his brother's innovation and has since used oil paints himself.

Brian does not dilute his colors as much as Ron does, so his dolls have a bit more color intensity, but because the colors are used only in certain areas, they look muted. Since the electricity in his house comes from a generator, he rarely uses a Dremel tool. The carving tools he uses are pocketknives of various sizes, chisels, a hacksaw blade, and small files. He uses sandpaper for polishing, and emery board to reach into narrow places. In earlier years he used rasps for smoothing the carved wood, but now he uses only sandpaper.

Brian carves kachina dolls, clowns, kachina sculptures, and portraits of Hopi people—a great variety of subject matter within and related to Hopi reli-

gious life. His wood carvings are very realistic, and most of them are slightly larger than Ron's. Until 1990 most of Brian's energy and time was directed to his Bacavi School, where he was both teacher and principal, so he could only devote the evening hours to his art. Now, however, the school has closed, and he devotes all his time to carving.

Ronald Honyouti

The youngest child of Rachel and Clyde Honyouti, Ron was born on May 20, 1955, in Bacavi. His parents still live in the house where he was born.

Ron Honyouti painting an Angaktsina (Longhair) doll

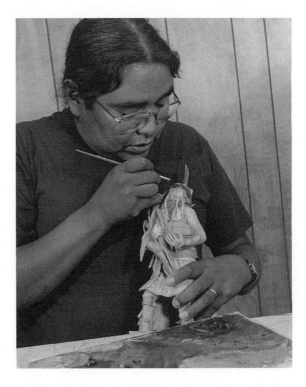

Ron lives with his wife, Clara, their young son, Mawasha, and little daughter, Felicia, in a double-wide mobile home in a large cornfield on the outskirts of Hotevilla. No water or electricity are available in this village, so the water has to be brought in, and electricity is obtained from solar roof panels. A dish antenna on the outside of the house attests to the modern lifestyle of this young family, which nevertheless adheres to Hopi religious traditions.

Every year at the Powamuya or Niman ceremony, Ron's little girl receives from the Katsinam a delicately carved kachina doll for which collectors would pay a hefty sum. These dolls hang on the wall of their living room, too sacred to be photographed. They are the gifts of the Spirit World, bringing blessings from the Katsinam to the little girl and her family.

Ron Honyouti's carvings are in a class by themselves. They are monumental wood sculptures scaled down to the height of only a few inches. Rarely are they taller than ten inches, becoming more delicate the smaller they get without losing their monumentality. Possessing a Honyouti kachina doll is the dream of many collectors.

Born into a family of kachina-doll carvers, Ron watched his father and eldest brother, Brian, carve as a little boy. When he was in the seventh grade he made his first doll and gave it to his sister. It was a Mudhead kachina doll standing on a base carved like a cloud.

Brian, eight years older than Ron, was the greatest influence on him. Ron was about fifteen when he started to carve in earnest. Soon both were working together, and Ron consistently improved his skills alongside Brian's experimental advances. From the very beginning, Ron carved his dolls from a single

piece of cottonwood root. He never used organic materials to dress his dolls but instead carved every detail directly into the wood. In those early years he used real feathers, but by 1978, when he graduated from high school, he was carving every feather by hand. Both Brian and he have great artistic talent, and over the years they have influenced other carvers with their ideas, experiments, and inventions.

Because the appearance of a Katsina cannot be altered in creating a small wooden replica of it, the only place where a carver can demonstrate artistic freedom is in the base of the doll. The Honyouti brothers have always carved the base from the same piece of wood as the figure; it is never separately carved or attached later. Ron credits his brother Brian with the idea of carving the motif of pueblo stone houses into the base. Talking to Brian, he modestly considers this the hallmark of Ron's carving, saying that Ron started it. This motif is generally liked by collectors and other carvers alike. It has been copied frequently and has been incorporated into the bodies of kachina sculptures by other carvers. The same is true of the scene of a Katsinmana climbing out of a kiva. The Honyouti brothers were the first to transform it into a wood carving, but now it is also carved by others. Ron smiled when he said, "We left this scene behind us years ago."

In 1987 Ron had a new idea on how to embellish the base of a Buffalo Maiden. On the back of it he carved a small niche in which he placed two Buffalo Dancers facing each other. Both were carved in high relief and on such a miniature scale that it almost took a magnifying glass to discover their identity. This sculpture won a first prize at the Annual Indian Fair in Sedona in 1987.

Ron's carvings are appreciated particularly for their fine detailing and precise carving on a miniature scale, but also for the subject matter he chooses. Often he likes to portray clowns in a very whimsical interpretation, creating unexpected and amusing depictions. Ron also carves scenes made up of several figures—for instance, a scene at the Powamuya ceremony in which a So'yok wuuti (One Who Enforces) Katsina threatens a small child whose mother tries to protect it. Ron has endless ideas for portraying Hopi rituals, Katsinam, and people. He also creates miniature kachina dolls about three inches in height, as well as small rattles. He uses an array of pocketknives and X-Acto blades for fine detailing.

Besides their delicate carving, Ron's dolls are recognized by their pale coloring. He uses varnish to close the pores of the wood, leaving the natural color and then applies color only in selected areas, diluting oil paints with mineral spirits to achieve his delicate pastel hues. Scratched reggae records or album covers serve as his palettes. A fan of reggae music, Ron knows he will find a new recording on his next trip to town. Ron and his brother Loren paint their father's miniature dolls and rattles, but they use stronger colors for those. Loren is also a very good carver, and together all three brothers travel to shows in Gallup, Santa Fe, and Albuquerque to exhibit their art.

Every December, Ron and Brian travel to Denver to participate in an art show to benefit the Archaeological Research Center at Crow Canyon, Colorado. Ron and Brian's carvings are represented by the Adobe gallery in Albuquerque, the Beyond Native Tradition gallery in Holbrook, Arizona, and the Adobe East gallery in Milburn, New Jersey. The annual Indian Market in Santa Fe, the Annual Indian Fair at the Heard

Museum in Phoenix in March, and the O'odham Tash in Casa Grande, Arizona, are other events where Ron and his brothers can be found with their art.

Von Monongya

Von Monongya is both an artist and a businessman, though one wins out over the other from time to time when he yields to pressures from either collectors or customers. In recent years, business affairs have monopolized his attention, but he plans to return to carving again as soon as time permits. His dolls are very much missed, because few carvers can finish the

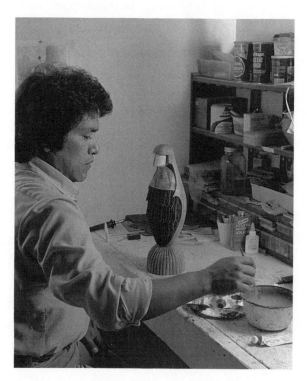

Von Monongya starts painting the Sa' lakwmana sculpture described earlier

surface of the wood as finely as he can. Other carvers openly admire him for his precision.

Now in his mid thirties, he taught himself how to carve kachina dolls when he was eighteen. His father never carved, but Von observed his uncle Alvin James Makya, who then lived in Bacavi. Alvin's naturalistic approach to carving the human body influenced Von in his early attempts and guided him toward his own realistic style of carving. His figures exude statuesque, almost majestic solidity. They are not overly active, yet they are alive and powerful. Their surface is very smooth, lines flow in elegant curves, and detail is kept to a minimum, all of which enhances the clarity of the surface.

Von enters his dolls at the Annual Indian Market in Santa Fe, where he regularly wins prizes. He has been sponsored by Gallery 10 in Scottsdale and had a large show at the Phillip Morris Gallery in New York in 1986. His dolls appear from time to time in galleries in Tucson.

Until about 1980 Von carved dolls in the traditional style. At that time he used wood preserver under his acrylic paints, a technique used by many carvers. In 1981 he experimented with semigloss wood preserver and noticed how much this brought out the grain of the wood. He found that it produced a much more beautiful finish than covering the wood with paint, and from then on he left large areas on the doll's bodies unpainted, using color only for embroidered designs, jewelry, and face designs. Kachina dolls finished in this new style won prizes in shows and at fairs.

In 1982 he went a step further in enhancing the surface carving of his dolls by introducing the electric

woodburning iron into the realm of kachina-doll carving tools. He uses it to simulate black hair, the barbs and configurations of feathers, the dark designs in sashes and embroidery, the outlines of design areas, and for other applications. Today the woodburning iron is used widely by carvers because it can serve as both a carving and a painting tool.

As the inventor of this technique, Von is an absolute master in the use of it. His strands of black hair are the finest and most precise ones on any kachina doll. Von carves both kachina dolls and kachina sculptures. The heads of the sculptures adhere to the prescribed design of the given Katsina to be represented, but anything below the head can be influenced by his creativity. For example, on a Hopi Sa'lakwmana he stylized the hair in the back so that it became one with the cape in a beautifully flowing line. The lower part of the body was also stylized, aesthetically balancing the base, which he carved in the form of a so-called melon pot from Santa Clara Pueblo in New Mexico.

In 1986 Von used acrylic paints for the colored areas. In 1987 he switched to oil paints thinned with linseed oil. Like other experimenting carvers, he constantly finds new tools and materials to improve on surface treatment of the wood and thus enhance his kachina dolls with ever-greater realism.

Cecil Calnimptewa and Muriel Calnimptewa

Cecil Calnimptewa is a carver artist who gives freely of his knowledge, skill, and time to anyone who respects these fine qualities in him. A master teacher,

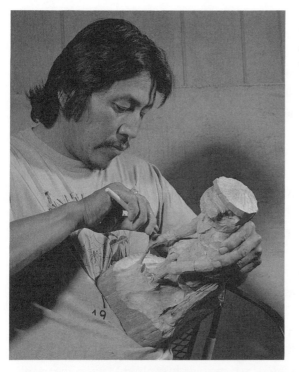

Cecil Calnimptewa carving a Sowi'ingwkatsina (Deer) kachina doll

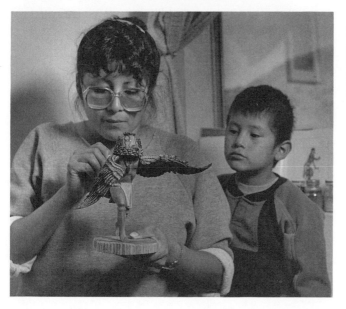

Muriel Calnimptewa paints a Koyongo (Turkey) kachina doll while her son Durand watches.

for some years now he has guided his relatives from
Moenkopi as well as his in-laws in the Polacca and
Keams Canyon area in his technique and style of carv-
ing. This includes the use of power tools, the X-Acto
knife, stains, and oil paints. Most of all it disseminates
his style of realism in body structure and action. How-
ever, every one of his "disciples" manages to depart
from these basics to develop his or her own style.
Cecil's, on the other hand, remains uniquely his own,
and any keen observer can recognize his dolls immedi-
ately. His carving style is particularly expressive.

Cecil was born on January 1, 1950, in Moenkopi.
He learned to carve kachina dolls by watching his
father. At age sixteen he began to make his first dolls
and was soon recognized as an exceptionally good
carver. He married Muriel Navasie, a niece of Feather-
woman, the famous potter. Muriel was a fine potter
herself before she met Cecil but switched to carving
kachina dolls when their first child Marissa, born in
1975, was still a baby. Cecil taught Muriel how to
carve, and she quickly made this art her own. While
raising four children she became famous as a carver
of miniature dolls and small kachinas. Her kachinas
ranged in height from six to eight inches and had
exquisite detail carving. But she excelled in making
miniature dolls, regularly winning top prizes with
them. Cecil and she often worked together as a team in
order to finish a doll, she carving the fine details and
he painting. Cecil taught Muriel basic carving skills,
but Muriel, in turn, taught Cecil how to refine his
detail carving. She preferred carving over painting
pottery, and the results of her preference made her
famous. Cecil and Muriel carved together every day
until Muriel's death in October 1988.

Cecil's technique changed considerably over the years. Until about 1975 he used the traditionally applied white wash under acrylic paints. When Bruce McGee encouraged him to carve the feathers on Kwaakatsina (Eagle) kachina dolls instead of using real feathers, Cecil also started to switch to a wood preserver under the acrylic paints. On other dolls, except for his Kwaakatsina dolls, Cecil still used feathers of nonendangered bird species, yarns, cloth, and small metal bells until 1980. Then, again encouraged by Bruce McGee, he started to carve feathers, clothing, and other paraphernalia directly into the wood. He soon mastered this challenge and went on to create very realistic representations of Katsinam. He also went from using a wood preserver to a true stain under the paints but found that water-based acrylics do not adhere well to an oil-based stain. In 1982 he solved the problem by switching to oil paints. These take longer to dry, of course, which slowed his work. Alkyd, an oil paint that dries three times faster than ordinary oil paint, came on the market in 1983 and was welcomed by Cecil and many other kachina-doll carvers. In 1987 Dennis Tewa, his cousin in Moenkopi, made Cecil aware of yet another oil paint, made in West Germany, that can be diluted with water, is easy to apply, dries fast, and adheres well to the oil-based stain underneath.

In 1985 Bruce McGee had one of Cecil's Eagle kachina dolls made into a bronze casting and had a bust of a Maswikkatsina sculpture cast in pewter. Both artist's copies are in Cecil's home.

A few years ago Cecil realized that using a Dremel tool could speed up his carving considerably. The Dremel tool had found its way into kachina-doll carving before

1982, but it was used only to make the fine lines on bird feathers. Cecil extended its use into a greater variety of applications and now surpasses any other carver in handling it.

After he has the fundamental form of the kachina doll carved, he continues to refine the wood surface and details with an X-Acto knife. His figures express a very realistic sense of motion and action. Watching him carve makes it clear that he really loves what he is doing. He works with a concentration and élan that are directly translated into his carvings. His technique is reminiscent of an impressionistic brush stroke, which adds an immensely vivid style to his figures.

Cecil is a master in the surface treatment of wood, creating a multitude of different textures that give realistic appearance and feel. All his works can truly be called wood sculptures, be they kachina dolls or Hopi figures. Cecil creates very complex kachina-doll scenes, representing several Katsinam, sometimes with clowns, all carved out of the same piece of wood. One such carving represents a majestic Kwaakatsina with two smaller Mudheads, one of which tethers a leg of the Kwaakatsina with a rope. This scene stands about thirty inches tall. Another carving of two Eagle Katsinam facing each other, also carved from one piece of wood, won the "Best in Kachina Doll Division" in 1988 at the Santa Fe Indian Market and was purchased from Cecil directly after the show by an eager collector for a very high price. Cecil's interpretation of a Nata'-aska Katsina shaking an upended clown, illustrated earlier, won the same prize in 1989.

Cecil went through very difficult times after his wife's death, but now he is again creating his art. He also continues teaching all those he taught before. Several of them, in turn, now teach others.

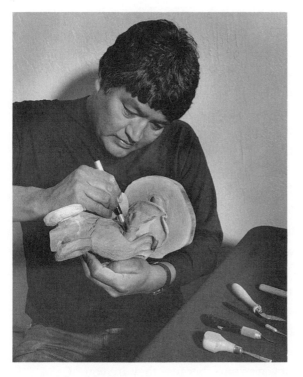

Dennis Tewa carving a Katsin-mana figure

Dennis Tewa

The carver-artist who strives for the greatest real-
ism in portraying Katsina dancers lives in Moenkopi.
Dennis Tewa was born there some forty years ago.
After spending his school years in Flagstaff and work-
ing several years in the Phoenix area, he returned to
Moenkopi in 1972. He has lived there with his wife
and children as a farmer and rancher ever since.

Dennis always had an interest in kachina-doll
carving but never tried it. Then one day in 1982 he
bought an unfinished doll from a carver who needed
money. He wanted to study the carving and use it
to experiment with his own carving techniques. By

challenging himself, he finished this doll three days later. This was the beginning of a career as a kachina-doll carver that has rapidly brought him fame and has won him so many prizes that he cannot remember their number.

In the beginning he worked with several smaller pieces of cottonwood root to make a doll, using glue to attach arms, legs, feathers, and other paraphernalia. He sold the dolls to galleries in Sedona, where Dan Garland recognized his talent and asked him to carve more. On one such trip to Garland's, with his dolls still on the front seat of his pickup, his cousin Cecil Calnimptewa came by and asked what he was doing. Dennis was too bashful to tell Cecil that he was trying to sell his own dolls and pretended to be looking for baskets. But when Cecil, who is a very respected and successful carver, saw the dolls on the car seat, he knew instantly that they were Dennis's creations. He said, "They are yours, because they are you." Cecil knows that carvers reveal their own personalities in their dolls. He also saw the talent in Dennis and showed him the basics of creative carving during a week when they worked together. Although Cecil said it would be too difficult for a beginner, Dennis carved an Eagle kachina doll. He took it to Bruce McGee at Keams Canyon Arts and Crafts (now McGee's Indian Art Gallery), who was astounded at this new talent. He bought the doll and entered it in the competition at the Annual Indian Market in Santa Fe, where it promptly won a higher prize than the teacher's entry. Dennis and Cecil worked together for another month, and Dennis's work improved rapidly. By now he was carving the whole doll out of one piece of wood. In Dennis's carvings the figure grows out of the root. A large piece of wood is needed to make outstretched

arms, extended headdresses, and the curves of capes and kilts. His sculptures usually stand sixteen to eighteen inches tall.

Dennis is a master at creating folds and wrinkles in capes and other clothing that look agitated by the wind. Hems curl up and capes seem to billow in a gust sweeping through the plaza while the Katsinam dance. Collectors regard these motions in his carvings as his hallmark. His dolls are very recognizable and very much in demand, so much so that he is two or three years behind in his orders. He admits to being a slow carver, joking that he must be the slowest of all. But he also has to take care of his cattle and horses every day and tend his fields in Moenkopi and Hotevilla. He considers both activities his priorities, in addition to participating regularly in ceremonial activities of the village and being called on by villagers to voice their opinions in tribal matters. All these are reasons why he does not enter more juried shows and is no longer interested in entering the Annual Indian Market in Santa Fe. He feels that the public should judge his work now.

Dennis continues to experiment with new tools, pigments, and stains, however. He works on improving the wood surface even further by trying to create a three-dimensional effect in certain textures such as furs, spruce neck-ruffs, woven sashes, and embroidered kilts. His aim is to achieve ever greater realism in form and action. Besides his almost flamboyant style of carving, which is at the same time elegant and daring, he uses his colors sparingly. Creating muted hues, he mixes wood stains with oil pigments—very much like the technique that Loren Phillips, his brother-in-law, uses.

Given the high regard that collectors and mem-

bers of the public who know his art have for him, Dennis's sculptures are well received and he can ask good prices. He can only produce eight to ten kachina dolls a year, and he always finishes one before starting a new carving. He deliberately carves only kachina dolls, saying, "I started carving kachina dolls in order to preserve this part of my culture." He carves his figures as realistically as he can so that people will later know exactly what Katsinam look like. A Hopi prophecy is very much on his mind. It states that when the Katsinam appear in ceremonies as entertainment, the Hopi Way will have come to an end.

Ros George

Now in his early forties, Ros George was born in Tuba City and spent his early childhood in Moenkopi, his mother's village. When he was ten years old, his family moved to Flagstaff. He attended high school in Flagstaff but returned in his sophomore year to Moenkopi to attend high school in Tuba City. It was then that he started to carve kachina dolls.

Ros is the younger brother of Dennis Tewa, and both are blessed with an exceptional talent for carving kachina dolls. Ros had made his name as a carver before Dennis started to carve. Then Ros fell on hard times and stopped carving for a while, finding no inspiration to do so. A few years ago he spoke of the difficulty of reestablishing his fame among dealers and collectors after a period of nonproduction. But that too is now in the past, and for the last six years his dolls have been placed in famous collections. Like his brother and other carvers in the forefront of carving,

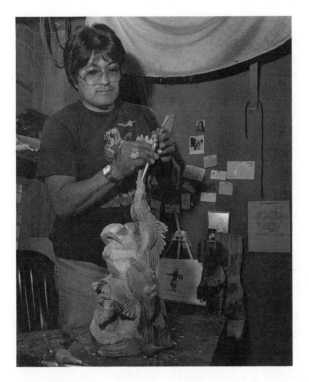

Ros George working on an elaborate Kwaakatsina (Eagle) kachina sculpture

he has advanced his skills in the surface treatment of the wood to create dolls that have made the transition to fine art.

Ros is a very spiritual person who cares greatly about life, and this outlook finds expression in his carvings. He feels that he was born to carve, and some years ago he quit his job as a bricklayer. He lives in Phoenix, returning to Moenkopi periodically for ceremonies. He says that he takes his "Hopiness" with him wherever he goes and that the meaning of his culture will always stay with him. It is his spirituality and his culture that he expresses in his work: "It never loses its meaning."

He does not intend to limit himself to kachina-

doll carving alone. Instead he tries to expand into areas other artists have not tried. Facial features intrigue him, and he is thinking of shifting his sculptural skills to stone. He is now collecting ideas as well as the skills required for mastering stone-carving tools.

Ros does not like to put himself in competition with other carvers because he respects other artists' work as much as his own. Ribbons from competitions mean little to him, but the appreciation his work receives from collectors and the public means a great deal to him. This is what he considers his awards.

Loren Phillips

Loren Phillips was born in Moenkopi on May 1, 1943. As a young man he learned bricklaying and became a journeyman. He was drafted into the army and served in Vietnam in 1967 and 1968. He was wounded three times and received three Purple Hearts. Upon his return from Vietnam he worked in Phoenix as a bricklayer until 1973. The recession at that time caused him to be laid off, and even though he found other employment, the pay was so low that he had to look for additional income. By 1981 he had been inspired by his uncle Wilson Kaye, an excellent kachina-doll carver, to begin carving dolls.

Now living in Moenkopi, Loren, like many other young carvers, took his dolls to Bruce McGee at the Keams Canyon Trading Post, and Bruce helped him sell them. Bruce was also instrumental in giving Loren his first big promotion and recognition in 1984. Loren is very thankful to Bruce, because since 1984 his work has been highly regarded by collectors and gallery

owners. For the last several years he has supported his
family solely by carving kachina dolls. Loren's wife,
Helene, is a sister of Dennis Tewa and Ros George.
They live with their son Corvin in a HUD subdivision
in Moenkopi.

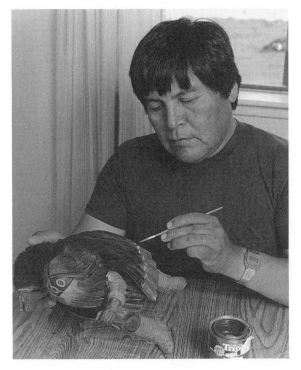

*Loren Phillips painting one of his
So' yok wuuti (One Who
Enforces) kachina dolls*

Loren is represented by Gallery 10 of Scottsdale
and Santa Fe. The owner, Lee Cohen, arranges several
gallery openings a year in which a number of Indian
artists are invited to show their latest creations. Loren
is always one of these artists. Lee Cohen also referred
television anchor Tom Brokaw to Loren when he
wanted to highlight a Hopi kachina-doll carver in an
interview aired nationwide in October 1987.

Loren occasionally enters a kachina doll in the juried Annual Indian Market in Santa Fe, where he often wins prizes. He also enters his work at the annual Hopi Artists Exhibition of the Museum of Northern Arizona, where he has won the "Best of Show" award. His many prizes are indicated by the long row of ribbons hanging on his living-room wall.

Loren participates in ceremonial dances and knows every detail exactly, as well as its symbolic significance to the kachina dolls he carves. He emphasizes that it is very important to him to represent the spirits correctly. He buys cottonwood root from dealers who come by. Loren prefers larger pieces from which he can cut several dolls. Often the wood is still fresh, and he lets it dry slowly so it will not develop any cracks. When he starts a doll, the form of that particular piece of wood predetermines which Katsina he will represent with it. His visualization becomes a feeling that grows stronger the farther along he is in his work. After days of carving, the shape of the human body in its spiritual transformation starts to emerge, and Loren becomes more confident that his feelings will take on the physical expression he desires. On the third day of my observing him he exclaimed, "It is coming alive!"

He likes to work in the very early hours of the day, when quiet allows for full concentration. His carving tools are pocket and hunting knives he buys at swap meets. He carves the finer details of patterns, textures, and decorative lines with pocketknives; for some textures he uses an awl. Carving and sanding a doll is a dusty business that he does outside the house in a metal shed. He then brings the doll inside for staining and painting. Loren has developed a method of applying stains so that the surface resem-

bles the glazes on old paintings. He coats his dolls
several times to give the surface a beautiful luster
through which the grain of the wood is still visible.
To achieve his colors, he mixes clear varnish with
oil paints.

Besides the meticulous execution and realistic
rendering of his dolls, Loren's hallmark is the bases he
makes for his dolls. When he rides his horse in the
washes around Moenkopi, he looks for pieces of cot-
tonwood that are twisted and gnarled, useless for carv-
ing but beautiful in their shape, to serve as bases for
his kachina dolls. He has quite a collection of these
pieces at home and selects each one carefully to fit a
particular doll. The only time Loren uses any glue
is when he fastens bases to the feet of his dolls with
wooden pegs. In his interpretation of the Eagle Kat-
sina, he has achieved a merging of the human body
with the wingspan and stance of an eagle in the wild, a
mingling of two realities that evokes the supernatural.

Orin Poley

Besides being a carver, Orin is also a farmer. He
was born in Bacavi on April 16, 1942. His mother is
from Moenkopi and is an aunt of Dennis Tewa, so Orin
and Dennis are first cousins. As a young boy, Orin
started school in Hotevilla, but soon his family moved
to Winslow, where his father found work. He grew
up and received his schooling there. His wife, Barbara,
was born in Winslow and also went to school there.
They have two grown children who work in Phoenix.
His son carves dolls when he finds the time and is,
in his father's words, "a good carver." Orin and Barbara
moved to Kykotsmovi in 1986.

Orin's father was a carver, and as a youth Orin helped him sand and paint his dolls. Inspired by his father, one day he started to carve his own doll, a Tsa'kwayna Katsina that his sister still has. All through the years in Winslow, where he worked as a carpenter, Orin maintained his carving as a hobby. In 1978 he quit his job and has been carving full-time ever since.

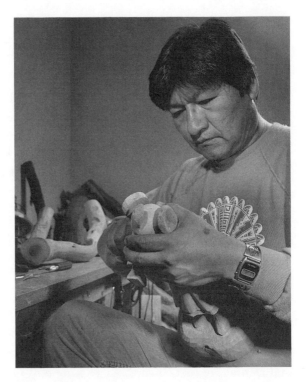

Orin Poley carving a Katsinmana doll

Early on, he refined his skill by examining Alvin James Makya's dolls on his visits to Bacavi. Orin was particularly influenced by the muscular structure of Alvin's dolls. In the 1960s he saw Alvin's unpainted sculpture *Princess* which impressed him. Alvin encouraged Orin to continue his carving, and it was through

Alvin that he met Arty Seeger, a gallery owner from
California who comes to the Hopi country regularly to
buy kachina dolls. She started to buy Orin's dolls and
arranged several shows for him in California. This
exposure made him known to various collectors.
Today he sells to collectors mostly through Bruce
McGee or directly to those who know him. Orin has
won many prizes; in 1988 alone at the Annual Indian
Market in Santa Fe he won both first and second
prizes. He also enters his work at the annual Hopi
Artists Exhibition at the Museum of Northern Arizona
and at the annual Indian Fair in Sedona.

Orin collects almost all his own cottonwood root
in the Verde River valley or along the Little Colorado
River near Winslow. Occasionally he buys it from
suppliers from Colorado. Carving a kachina doll from
another kind of wood is unthinkable for him, because
that would not adhere to tradition and would take
the art out of the religious realm. He might, however,
try a sculpture in another wood.

Orin works on several dolls and sculptures at the
same time, but he is very meticulous in his work, and
it takes him several weeks to finish one figure. His
carving tools are pocketknives, chisels, rasps, and
handsaws. He spends much effort and time on sanding
to produce a smooth surface that gives the soft wood
an almost velvety touch. To seal the wood, Orin prefers
Watco Danish Oil over other wood preservers because
he believes it soaks in better and makes the finish
more matte, which is more to his liking. Depending on
how porous the wood is, he applies one or two coats
of Danish Oil. The twenty-four-hour waiting time
between coats allows him to work on other carvings as
well. His stains are very diluted acrylic paints for areas

where he desires a color to be prominent. For larger
areas where the color should appear less bright, Orin
uses thinned oil paint. Acrylic paints give a more
intense hue, and he uses both oils and acrylics on the
same carving, depending on the effect he wants to
achieve. To the eye it is indistinguishable which one is
which.

All his carvings, both kachina dolls and kachina
sculptures, are carved from one piece of wood. He also
carves Butterfly Maidens with elaborate headdresses
and complex sculptures in which he incorporates
symbolic motifs into the base or into the body of the
figure. Sometimes the shape of the wood leads him
to create a double figure—for instance, a Hopi
Sa'lakwmana and a Sa'lakwtaqa from two roots that
branch off from a common juncture. His sculptures
grow out of their wooden shapes, denying the human
form in the lower section yet blending into upper bod-
ies and heads that are as realistic and true to their
Katsina identifications as they can be.

Often these sculptures express more symbolic
and supernatural intensity than realistic carved dolls
with legs and arms, though the body proportions of
Orin's figures are very natural and anatomically cor-
rect. These carvings are not only of excellent execution
but are also impressive in their conception. They seem
to be imbued with a stately grace and power of their
own. Although they always observe the traditional
limits on movement and appearance of the Katsina
they represent, from time to time his dolls reveal inno-
vations in rendering that appeal to the connoisseur.
These are the kachina dolls that usually win the prizes
at juried shows.

Jim Fred working on an Angwushahay'i (Crow Mother) kachina doll

Jim Fred

Jim was born on April 25, 1945, in Winslow, Arizona. Since 1987 he has lived with his wife and three children in Bacavi, his home village, where his mother and most of his brothers and sisters also live. For ten years, from the late 1960s to the late 1970s, Jim worked as a technician for Walt Disney Productions in Los Angeles. There he helped set up big color spectacles for large shows and worked in the darkroom making color reproductions and prints. He enjoyed working for Disney, but his wife urged him to return to Phoenix, where they could raise their children close to her relatives. Jim found a job working with the mentally handicapped, work that he likes. In 1987 he transferred to Keams Canyon. He left his job in the

fall of 1989 and now supports his family by carving kachina dolls. Jim also participates in kiva and ceremonial activities. His wife is a secretary in the day school at Kykotsmovi.

When Jim was a teenager, everybody around him carved dolls except his father. He watched the others carefully and made his first dolls when he finished high school in 1963. At that time he used a white undercoat on sanded wood before painting it with poster paint. While he lived in Los Angeles he made only a few dolls for his nieces once a year, but as soon as he came back to Arizona he made frequent trips to Bacavi and to Hopi religious ceremonies and began making more kachina dolls. In these he used fewer organic materials and switched to acrylic paints, using white gesso to prepare the wood for painting. He carved arms and legs separately and glued them to the body, the usual technique.

In 1986 he began to use Alkyd oil paints. A few years earlier he had changed his carving technique. He selected larger pieces of wood so he could carve the whole figure—including arms, legs, and bases—out of the same piece of wood. These are the dolls that he sells to dealers and collectors. Bruce McGee also helped him find collectors for his art; he encouraged him to continue carving and made his dolls known. Jim says he owes a lot to Bruce and appreciates his "critical and constructive suggestions." He still sells mostly through Bruce and feels obligated to give him first choice. He does this out of respect and because he considers him very fair.

In his carving Jim uses hand tools. He owns a Dremel tool but rarely uses it because he has not developed the skill to use it effectively. He uses a

woodburning tool only for texturing hair and the spruce ruff around the neck, hardly ever for feathers. He carves all details with his pocketknives, leaving the most delicate parts for last, for fear of breaking them. After sanding he uses Minwax, a wood preserver, to seal the pores of the wood. In the areas that he wants to keep bare and without colors, he applies a second coat of Minwax. Jim finds that two coats are sufficient; any more would make the surface too shiny. He thins the oil paints he uses with turpentine or mineral spirits, which gives the colors a muted intensity.

Jim's dolls have their arms and legs in dancing position or in the stately stance in which they appear in the plazas. He does not give them overly active motion, believing that this is not authentic. He maintains that in carving a kachina doll he has to stay within certain limits as to the particular Katsina's stance, costume, and colors. As he puts it, "All is already said." Carving a kachina doll does not provide him with as much freedom of expression as when he carves what are called sculptures, which are wood carvings of cylindrical form with no legs and little if any indication of arms, but with the fully carved faces of the Katsinam. In form they are reminiscent of muringputithu, in which only the heads are fully carved in order to identify the Katsina.

Jim carves just as many kachina dolls as sculptures, and he likes to switch from one to the other. In creating a kachina sculpture he can "put himself into it" and express himself better in his carving. He has to depict the features of the head correctly in every detail, of course, but the rest of the body can be imbued with as much feeling and expression as he cares to put into it. The contour, line, and flow of the piece of wood

directs him in his carving. If at the end he feels good about a carving, he knows that other people will also like it. His work becomes part of himself, he admits, and he sometimes finds it hard to part with it. Every new piece of wood offers him a new challenge and a new satisfaction.

One of his Angwushahay'i (Crow Mother) kachina dolls is in the Heard Museum in Phoenix, and its image has been used on a postcard. Jim believes that he is known for this kachina doll. He enjoys making Hotevilla clowns and Butterfly Maidens because he also likes to carve faces. He works on only one doll at a time, finishing it in two or three weeks.

Neil David, Sr.

As an artist and member of the Artist Hopid group, Neil David has influenced the American Indian art world in general and Hopi art in particular. A Tewa from Polacca, Neil was born on June 4, 1944. His father died before Neil was six, and he was raised under the influence of his grandfather, who carved "all the time." When he was twelve, Neil took up the craft, carving in the traditional style of shaping the body and then adding mouthpieces, ears, and small, thin boards for the sash. Everything else was painted on, and the head was decorated with real feathers. Soon he experimented with attaching the arms, and by 1957 he was carving the legs in the dancing stance, creating true action dolls. In his freshman year in high school he sold his first carving. He was drawing a lot of sketches then, which caught the attention of Byron Hunter, who at the time managed the old stone-built

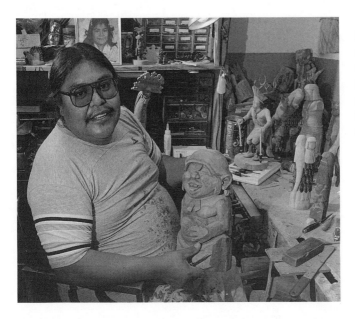

Neil David with a large clown figure. On the work table are a multitude of kachina dolls and kachina sculptures in various stages of completion.

store in Polacca owned by the McGees. During Neil's high school years from 1959 to 1963, Hunter was able to sell his drawings and paintings, which gave the young artist great encouragement. Once in a while he also produced and sold a carving.

During a Christmas visit to Polacca in 1963, a room in his mother's house burned and he rebuilt it, staying in his home village through 1964. In early 1965 he was drafted into the army, spending his basic training in Georgia and his tour of duty in West Germany until 1968. After his return, he dedicated his time to painting and drawing, spending much of his time with his friend Michael Kabotie, son of Fred Kabotie, the founder of the Hopi Silversmiths Guild. In 1972 their friend Terrence Talaswayma and they formed the Artist Hopid group with financial backing from the Silversmiths Guild. In 1973 they were joined by Delbridge Honanie and Milland Lomakema. All of

them were painters but also very good kachina-doll carvers. Neil made a name for himself as a painter, carving dolls only occasionally. By 1974 the five artists had moved into one of the shops at the Hopi Cultural Center on Second Mesa, where they shared a studio. They were a great inspiration to each other and gained a national and international reputation. They remained together as a creative community for another four years.

In the end, disagreements over finances severed their relationship with the guild. Neil then started to carve more, using contacts he had made over the years. In the late 1970s and early 1980s his business boomed and he had more orders for kachina dolls than he could handle. Artist Hopid still exists, but since the breakup the members have worked out of their homes, and the cohesiveness of the group is gone. One of the members, Terrence Talaswayma, has since died of diabetes. The group's paintings, however, are still shown at annual occasions at the Hopi Cultural Center's museum and at other Indian markets.

For the last several years Neil has put more effort into carving, because kachina dolls and sculptures sell better than paintings, though it takes him longer to carve a doll. He still does many pen-and-ink drawings, which are often used on T-shirts, shopping bags, and other utilitarian articles. His paintings are purchased by museums and collectors and are sold as art prints. He is known for the spirituality of his paintings, and he also expresses this in his kachina sculptures, several of which have been cast in bronze. His trademark is his clowns, however, which he draws and carves in very vivid motions and realistic actions.

Neil David's paintings and kachina-doll carvings

have appeared in many museums and galleries throughout the country. He earns prize ribbons in every show in which his art is presented. In 1990 for the first time he himself entered two paintings and two kachina dolls in the Hopi Artists Exhibition in Flagstaff. One of the paintings won the Curator's Award, and one of the dolls, a Kòoninkatsina (Havasupai), won first prize. He hopes these prizes will bring him more orders from collectors.

Neil considers it important that his work be seen by the public. He usually carves what he likes and what comes to his mind, but if someone orders a specific kachina doll or clown, he makes it for that customer or collector. If he happens to have a finished piece that is not an order, he sells it to whoever comes to his door. He also sells his dolls to Bruce McGee in Keams Canyon, who has been a loyal supporter, and to Chester Lewis in Holbrook.

Neil lives in Polacca with his wife, Dealva, and their three sons and one daughter. His oldest son, John, followed him in becoming a painter.

Lowell Talashoma

Lowell Talashoma was born in Moenkopi. His mother is Navajo, his father is Hopi and is also a well-known carver. He started carving when he was ten years old. He spent the fifth through the eighth grades in Salt Lake City, where his teachers and classmates considered him an artist. There his foster parents encouraged him to carve anything his heart desired out of scrap wood. These creations always won prizes in school competitions. At the same time he also

painted and wrote poetry. Besides decorations, he painted the portraits of twenty-five American presidents on the walls of the school. In 1966, at the age of sixteen, he returned to Moenkopi to enter Tuba City High School, graduating in 1970.

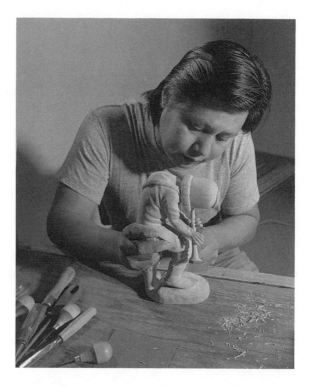

Lowell Talashoma carving a Kookopölö, a Humpbacked Flute Player kachina doll

Lowell carved his first finished doll in 1963. This was a Mudhead kachina doll carved from a single piece of wood. His next dolls, however, were carved in the then-conventional manner, with separate pieces glued together, given a white undercoat, and painted with acrylics. Since 1969 he has carved dolls from single pieces of wood.

The greatest influence in Lowell's carving came

from Alvin James Makya. Lowell studied the proportions, musculature, and facial expressions of Alvin's carvings, and he must have studied them well, for his figures portray the human body in full action and in realistic proportion. He also learned from Alvin that it is necessary to carve every little detail into the wood if the doll is to be cast in bronze; painted features will not reproduce in the casting and will be lost. Lowell created a dozen dolls for this procedure in the early 1980s.

Lowell has always supported his family with his carving. He uses a handsaw to cut the raw pieces of wood and the main angles, and then uses chisels and pocketknives to finish the work. He owns a Dremel tool but uses it only to put his signature on the base of the figure. He applies synthetic clear varnish to close the pores of the wood when it is of soft consistency. He does not like any stain or color in his varnish, preferring the natural shades of the cottonwood root in those areas where flesh tones and the natural colors of cotton or buckskin are desired. When the cottonwood is hard, he paints Alkyd oils directly on it, applying varnish later.

Lowell sells his dolls to Dan Garland in Sedona, Bruce McGee in Keams Canyon, Chester Lewis in Holbrook, the Adobe Gallery in Albuquerque, and art stores in Flagstaff. Sometimes he also sells to the gift shop at the Museum of Northern Arizona.

Jonathan Day

Born on September 17, 1951, Jonathan Day grew up in Hotevilla, where he watched the men carve

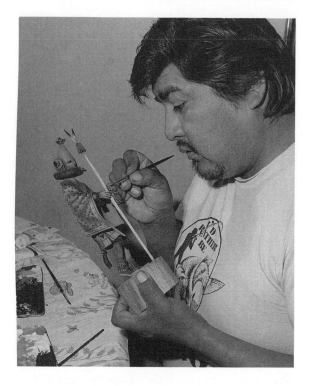

Jonathan Day adding the last brush strokes needed to complete an Ahooli kachina doll

kachina dolls. Early in life he started to carve his own dolls in the style prevalent at the time. In the fifth grade he sold his first doll for ten dollars to Wayne Sekaquaptewa, who owned an arts and crafts store in Kykotsmovi.

Jonathan became a carpenter by trade, which familiarized him with the qualities of different woods, knowledge he has carried over into his kachina-doll carving. When in the late 1970s the law to protect endangered bird species was strictly enforced, buyers became aware that they could not purchase dolls ornamented with their feathers. Jonathan says that dealers and collectors would ask him what kind of feathers he

used, and rather than face legal problems he started
to carve the feathers. He also began to carve other
parts that he had usually added on with smaller pieces
of wood or other organic materials. Since 1980 he
has earned his living by carving.

Jonathan's dolls are slender and seldom larger
than eleven inches tall. All are carved out of single
pieces of wood, including the bases. He carves regular-
sized dolls, miniature dolls, and occasionally sculp-
tures. He is impressed by the work of the Honyouti
brothers, but he strives for a refined and delicate style
of carving that is his own. In particular, his application
of acrylic paint sets his style apart from other carvers.
He prefers to carve Katsinmana and Nuvaktsina (Snow
Maiden) kachina dolls, but if asked, he can create a
great variety of dolls.

Jonathan lives in Hotevilla with his wife, Yvonne,
who works at the tribal office in Kykotsmovi, and their
three children. Dealers and collectors come directly to
his house to buy his exquisite kachina dolls, which
have won prizes over the last ten years in numerous
competitions and shows. Jonathan also sells his dolls
at various Indian markets, such as the Pueblo Grande
Indian Fair in Phoenix, held every December.

Wilmer Kaye

Wilmer Kaye was born in 1952 in Hotevilla and
is the son of Wilson Kaye. His famous uncle, Charles
Loloma, has always given him great encouragement in
his carving. Wilmer has made himself known for his
stylized, elongated sculptures of kachinas.

I talked with Wilmer briefly in 1986, when he told me that he taught himself to carve dolls and could not remember when he first started to make sculptures. Even though his father, who is now deceased, was a very good carver, Wilmer did not learn from him. In fact, he started carving kachina dolls before his father took up the art.

Wilmer Kaye with his Katsinmana sculptures

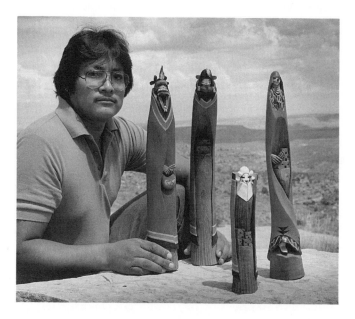

Wilmer moved to Zuni in 1987. While still in Hotevilla, he carved with his friend Jonathan Day, and for a while both created sculptures. He can be found at many Indian art shows in Arizona and New Mexico, where he sells his sculptures. He has won many prizes with them; in 1990, his magnificent, tall Palhikwmana/Sa'lakwmana sculpture, which merges the two Katsinam into one figure, won a first prize at the Hopi Artists Exhibition in Flagstaff.

John Fredericks

John Fredericks favors carving kachina sculptures. The Museum of Northern Arizona featured him in a one-man show and in the large exhibition called "A Separate Vision" in 1988, which toured the United States beginning in 1990. His style is now being recognized by art galleries and collectors.

John's work is now so much in demand that he is always five or six dolls behind, but he pushes himself to keep up with his orders and considers his carving his job. There are days, however, when he does not carve at all, to give himself time to clear his mind.

John Fredericks starting one of his kachina sculptures

John was born on December 26, 1949, in the village of Kykotsmovi, located at the foot of Third Mesa. He now lives in Phoenix. He married in 1970 and has a son and a daughter. He used to earn his living as a heavy-equipment mechanic in Phoenix but became interested in carving when he watched his friend Wilmer Kaye carve kachina sculptures. In the beginning John's carvings resembled those of Wilmer, but later he developed his own style. He usually carves sculptures rather than kachina dolls because he prefers to work with those pieces of wood that lend themselves to the shapes of sculptures, and in carving sculptures he can retain the natural shape of the wood. He used to find his own wood but now buys it from a dealer who knows exactly what shapes he likes. John thinks that the reason for the popularity of sculptures is that non-Hopi buyers are not familiar with the meaning of the Katsinam and kachina dolls but recognize the spirituality in kachina sculptures, besides being intrigued by their shapes.

Remarkably, John carves exclusively with a utility knife, even for the finest details. I have not encountered any other carver who uses this kind of knife. John says it allows him to change blades frequently and thus always to have a sharp edge. Only for very hard-to-reach places does he use a carefully sharpened pocketknife. He does not use stains; instead he enhances the grain of the wood with a light application of lemon oil. For coloring he uses acrylic paints. His initials on the bottom of his carvings identify him as the maker.

In 1989 and 1990 John entered his work in the Hopi Artists Exhibition at the Museum of Northern Arizona and won prizes both years.

Jimmie Gail Honanie and Aaron Honanie

The Honanie brothers of Moenkopi produce realistic action dolls ranging in size from twelve to eighteen inches. A third brother, Ernest, is also a fine carver. All were born in Kykotsmovi and all married women from Moenkopi, where they live.

Jimmie Gail Honanie carving the details of a fox tail on a Taawa-katsina (Sun) kachina doll

The way in which Hopi artistic talent often develops can be seen in the careers of Jimmie Gail and Aaron Honanie. Both are friends of Loren Phillips, whose artistry in carving has been an inspiration to them. Loren advises and shares his carving experience with them, and Jimmie Gail and Aaron use Loren's carving techniques and materials. Still, even

though Loren's influence can be detected in their work, Jimmie Gail and Aaron both have their own styles.

Before Jimmie Gail watched Loren carve, he produced dolls clothed with yarn, feathers, cloth, leather, and metal bells, painting the body all over without using stains. In 1983 he started to carve the clothing and ornamentation in wood, still using acrylic paint, and gradually his technique came to resemble Loren's.

Aaron Honanie carving a kachina doll

He uses Minwax mixed with specific pigments for coloring each kachina doll. His main carving tool is the X-Acto knife. Jimmie Gail, who works at a garage and auto parts store in Tuba City, carves only part-time, which makes his dolls harder to find. Like most

carvers, he incorporates a base into the figure of those dolls he sells.

Aaron Honanie was born in 1953 and at the age of twelve was initiated into a Hopi men's society. He made his first doll for his mother, carving it from several pieces of cottonwood root, with parts glued to the body and painted with acrylics.

Aaron worked for the Navajo Communication Company in Tuba City until 1984. That year, his friend Loren Phillips invited Jimmie Gail and him to come over to his house and watch him carve dolls. Aaron was so impressed that he decided to change his technique. By the end of the year he was carving kachina dolls full-time, and he has supported his wife and three children with his art ever since. Aaron praises Loren, saying, "I had a good teacher!"

He often works with Loren, watching him, and by doing so steadily improves his own skills. Aaron says that carvers in Moenkopi freely exchange their techniques and tell each other if they find a new tool, paint, or wood stain, or if one of their experiments has achieved a better or easier way of producing a doll. The carvers of the village half-jokingly call themselves "the Moenkopi Boys."

Aaron enters his dolls regularly in Indian art shows, and his work can be found at the Annual Hopi Artists Exhibition of the Museum of Northern Arizona, where he has won prizes. He sells his dolls to Bruce McGee and to collectors who place orders with him.

John Kootswatewa

John Kootswatewa started carving for commercial purposes in 1986. He was tutored by Cecil Calnimp-

*John Kootswatewa
carving the hands of a
Talavay (Morning)
kachina doll*

tewa in his early attempts, and occasionally he still
is today. He is married to Hariette Navasie, a sister of
Cecil's deceased wife, Muriel.

Born in 1955, John started to carve in 1973 after
graduating from high school. He served in the Marine
Corps for four years, sailing around the world twice
and spending a year in Japan. After he married he
supported his growing family with work other than
carving. But Cecil's and his families would meet often,
and at such gatherings he would watch Cecil and his
brothers-in-law carve. His interest in carving kachina
dolls was reawakened. On one such occasion, Cecil
put a piece of wood in his hands and said: "Start here."
Having played musical instruments all his life, John
has nimble hands capable of working with fine details.
Since 1987 John has supported his family of six solely
by carving kachina dolls, always under the watchful
eye of Cecil, who carves with John and his other rela-

tives. John uses the same techniques of carving and the same stains and oil paints as Cecil does.

As of 1990, neither Hariette nor he had entered a competition. They sell most of their dolls to Chester Lewis, the owner of Tribal Treasures in Holbrook. They also sell to Bruce McGee in Keams Canyon, Von Monongya's gallery in Oraibi, and the Honanie Arts Store below Second Mesa.

Hariette Navasie Kootswatewa

Hariette, who signs her dolls "Hariette Navasie," began to learn from her sister Muriel in 1987, a year

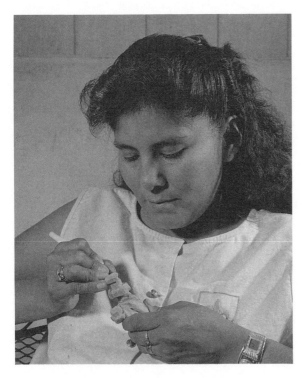

Harriette Navasie Kootswatewa carving one of her miniature kachina dolls

after her husband John began to learn from Cecil Calnimptewa. Hariette had her sister as a teacher only for a little over a year before Muriel died, but this fundamental training was enough to reveal Hariette's great talent in carving miniature dolls. Occasionally she also makes larger dolls.

Harriette is now raising five children, two of them twins, and has lived through the loss of her first child. She and her husband John work as a team in carving dolls. They share their experience and find joy in creating naturalistic action dolls.

Hariette's carving techniques, stains, and paints are those she adopted from Muriel and Cecil. Because her knowledge is not yet extensive, from time to time she has to ask Cecil for the proper color application on certain kachina dolls. Her execution of detail is so fine and careful that her dolls sell readily.

Kerry David

Within the last few years, one of Leslie David's sons, Kerry, has made a name for himself as a very good young carver. Kerry produces excellent realistic representations of clowns and Katsinam in regular and miniature sizes. It takes him about a month to finish one of the larger dolls.

Kerry was born on May 5, 1963, in California. Growing up, he saw his father carving in the evenings and picked up the art himself when he was only eight years old. The family had returned to Polacca when Kerry sold his first doll—a Mongwu (Horned Owl) kachina doll—to Bruce McGee. This figure was painted all over and had been carved in his father's

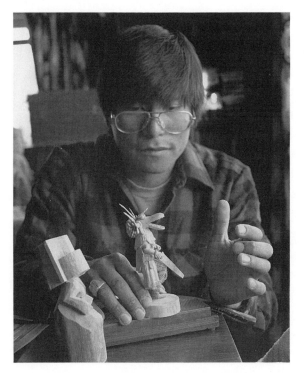

Kerry David with a small-scale Nata' aska kachina doll

style, with several parts glued together. His subsequent dolls were clothed in real fabric and were adorned with leather, yarn, and feathers. When he was sixteen he began to take carving seriously and stopped using organic materials. Like his father he still carved separate pieces and used a latex paint that he found quite unsatisfactory.

Experiments with paints and stains followed until he settled on acrylics. His famous relative, Neil David, advised him to thin the acrylic paint to achieve something like a wash. But Kerry found that this did not adhere well to the linseed oil he used as a wood sealer. He also tried oil paints but found that they took too long to dry. His present combination of Minwax as a

sealer and acrylics suits him fine, and his buyers seem to agree.

Collectors began to notice Kerry's fine work in 1983 and started placing orders with him. Now his work is entered in shows and finds wide recognition. Only once has Kerry entered his dolls himself in a juried show, the 1987 Colorado Indian Market in Denver, where he won the award for being the best in its class plus one third and two first prizes.

Kerry is married to a granddaughter of the famous potter Joy Navasie, called Frogwoman, and the young couple have a baby boy. To move his carving tools out of the reach of their curious toddler, Kerry now works at Phil Sekaquaptewa's Hopi Gallery below Second Mesa. When Kerry is not carving, Phil teaches him the art of silversmithing.

Delbridge Honanie

Besides being a painter and a carver of kachina dolls, Delbridge Honanie has chosen to depict his people through symbols of Hopi myth and spiritualism in wood sculptures.

Born on January 7, 1946, Delbridge received his early education on the Hopi Mesas but moved to Phoenix to attend the Phoenix Indian School, from which he graduated in 1968. For two years he studied at the Institute of American Indian Arts in Santa Fe, receiving his diploma in 1970. He returned to the Phoenix Indian School as a teacher of arts and crafts for an additional two years. In 1972 he was initiated into the Hopi men's society and was bestowed with his

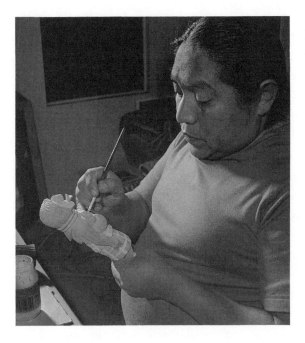

Delbridge Honanie painting a Hoo'e kachina doll

Hopi name, Coochsiwukioma, Falling White Snow. After his initiation his godfather taught him to carve kachina dolls, and he had the opportunity to see old dolls that were painted in pale vegetable colors. He liked this older style very much and decided to carve his own in a similar fashion.

Delbridge has been a painter since high school and is now recognized as one of the best Hopi painters. He has painted several murals and has been a member of the Artist Hopid group since 1973, though he now derives his main income from his carvings.

His kachina dolls differ from his other carvings insofar as they are painted all over the body in almost undiluted acrylic paints, and unless they are quite tall, they usually have no stands. Two such kachina dolls

that he made for his wife, Lorraine, for Niman dances
had stands because they were too large to hang on
the wall.

Delbridge says "I never carved anything in real
action." Still, he always seems to be inventing some-
thing new within his own style. He carves kachina
dolls, Hopi dolls—as he calls them—which are carv-
ings of Hopi Social Dancers and clowns, and Hopi
sculptures. These sculptures have faces reproduced
from Awatovi murals, with two rectangles for eyes and
a triangle for a mouth. Delbridge says, "This is the
face that Hopi have always depicted themselves with."

He also carves small, flat dolls—putsqatihu—
and larger flat figures—putstihu taywa'yta—to hang
on walls. Generally, Delbridge creates more Hopi
sculptures than kachina dolls. His sculptures depict
Hopi people in conjunction with symbolic motifs of
corn, clouds, and hands. Often he prefers to use dark
pieces of cottonwood root, eliminating any stains.
He uses linseed oil to close the pores, or, if the wood
has a dense structure, he paints his acrylics directly
onto it. His acrylics are thinned so much that he calls
them acrylic washes. They have a pale appearance and
give his dolls the feel of the old kachina dolls. The
wood color resembles flesh tone. Occasionally Del-
bridge treats his dolls after painting with a coat of
linseed oil "to bring out the colors."

While still in his teens, Delbridge made large,
elongated cottonwood-root sculptures. In the mid-
1960s he made ceramic sculptures but returned to
cottonwood root in the early 1970s. In the early 1980s
he carved four monumental wood sculptures that had
pueblo scenes with corn and hand symbols. These

were cast into bronze. Over the years he has won many awards and prizes.

About his carvings Delbridge has this to say: "My sculptures are of everyday things. They are not from scenes from our ceremonies because those events are sacred and secret. Mine are scenes of our daily life: the working, the planting, sometimes a few of our legends, but mostly Hopi life. Corn represents the mother who makes more children; at every Hopi event, corn is there. The hand is the earth, supporting the corn and all the people; the clouds and the rain are what make the corn. The human figure is just an ordinary person, but spiritually it can be anybody, and the rainbow gives power to the person. The feathers are for prayers, which in a sense is what all these sculptures are— prayers not just for me, my family, or my people, but for people all over the world and for all things—ani- mals, plants, water, clouds, sun, stars, including non- living things—prayers for everything."

Henry Shelton

Henry Shelton has been known for his museum- quality kachina dolls since the late 1960s. He was born in Kykotsmovi, but he does not know exactly in what year. "It was in February in the 1930s," he says. As a boy he would watch his uncle carve dolls that were sold to tourists who came by.

Henry and his brother Peter, who still lives in Kykotsmovi and who is also an excellent carver, were influenced by the skill and success of their uncle. When he was still little, Henry made a "stiff" doll that

Henry Shelton painting a Naan-gösohu (Chasing Star) kachina doll

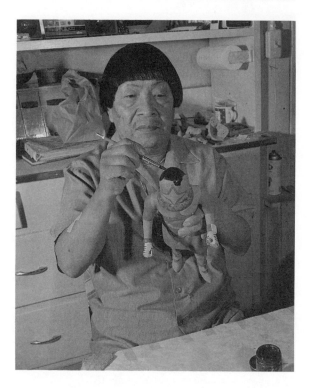

was so good that he could sell it. By the early 1950s Henry started to carve his own dolls with more earnest intentions of selling them. In 1957 he moved his family to Flagstaff for its job opportunities and started working at Food Town. As he recalls, he was "semi-good" at carving then.

The Museum of Northern Arizona offered him a job in 1961, and within a few years he had become the preparator. Edward B. Danson, director of the museum at the time, encouraged Henry in his carving, and the refinement of his work increased. Henry recalls that he was "real good at carving by 1966."

In 1964 Clay Lockett, proprietor of an arts and crafts store in Tucson and manager of the gift store at

the Museum of Northern Arizona, bought an unpainted Hemiskatsina kachina doll Henry had made and had it cast in bronze, the first attempt at the procedure in this medium.

With a secure income at the Museum of Northern Arizona, Henry could dedicate his time to creating kachina dolls for the museum's collection. Two excellent dolls, a Hemiskatsina and an Eagle Katsina, found their way into the collection of the Arizona State Museum in Tucson, thanks to Danson. Another Eagle kachina doll, which stands more than twenty-five inches tall, is in the Goldwater Collection of the Heard Museum in Phoenix.

Over the years Henry has demonstrated his work in many places—in 1985 as far away as London, where he was greeted by royalty. In 1986 he undertook a demonstration tour of southern California. He has also brought the art of Hopi kachina-doll carving to Kansas, Texas, Florida, Illinois, and other states.

Henry continues to use the style of carving he developed in the 1970s: he usually carves the arms separately and glues them on, then paints the dolls all over with acrylics without stain. He tried stains in the late 1970s but found that his dolls sold better if they were painted in bright colors all over. He also uses organic materials like yarn, leather, metal bells, and real feathers. He uses partridge and pheasant feathers for the larger feathers and chicken feathers where fluffy, white feathers are needed. His dolls are usually twelve to fourteen inches tall with an attached base. On request, he will carve a doll from one piece of wood, but that takes him longer to make and he charges more for it.

In 1978, when he left the Museum of Northern

Arizona, Henry took up martial arts and has a black belt. He earns his living by carving and demonstrating. His wife Mary makes miniature kachina dolls. Both can be seen selling their creations at Indian markets in Arizona.

Colleen Talahytewa

Born in 1968 in Moenkopi, Colleen Talahytewa is still very young, but she has made a name as a kachina-doll carver, besides being a wife and the mother of two small children.

Colleen was introduced to kachina-doll carving

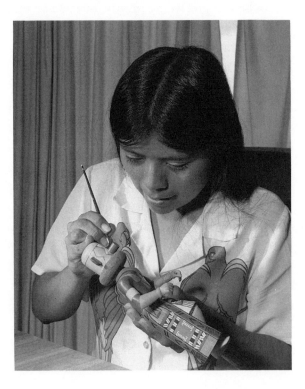

Colleen Talahytewa painting a Paatso (Cockle Burr) kachina doll

by her family while she was growing up. Her father, Stacy Talahytewa, has carved dolls for sale for thirty years, providing all the family's income from his work. Stacy carves arms and legs separately, glues them to the body of the carved doll, and adorns the heads with chicken or turkey feathers. His dolls are relatively small and are painted over the whole body. Colleen's mother, Louise, is from Cochiti Pueblo in New Mexico, where women do not carve kachina dolls. All five brothers and six of Colleen's seven sisters carve kachina dolls. Colleen and her brothers and sisters grew up seeing their parents carve for an income, so it was natural for her to pick up the craft when she was in her teens and to earn money from it.

Her dolls are larger than her father's—about ten inches high—and they are very well proportioned and finely executed and painted. She uses linseed oil to close the pores of the wood and then paints over it with acrylic paints, leaving some parts, such as the kilt, unpainted to simulate the light color of cotton. Like her father, she carves arms and legs separately and glues them to the body. The only organic material she uses is chicken feathers on top of the head. Colleen goes with her family to shows and Indian markets to sell her dolls or sells them directly to buyers who come to her house.

Richard Pentewa

Richard Pentewa is the son of Otto Pentewa and was born in Kykotsmovi on April 12, 1927. Otto, who died in 1961, was well known for his Early Action style of dolls in the 1930s, '40s, and '50s. He carved arms and legs separately and attached them to the

body with nails and glue. The body was first painted with a white undercoat and then with tempera or poster paints. The surfaces of Otto's carvings were a bit rough, having been smoothed only by a rasp. In the early 1940s, when Richard was fourteen or fifteen, he started to help his father with the sanding, using sandpaper, and from then on the dolls had a smoother finish.

Richard Pentewa using a rasp to smooth the arms on one of his carvings

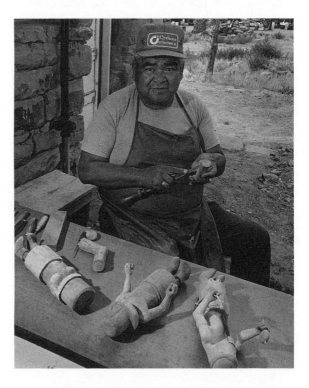

Richard served two years in the army, returning from Korea in 1955, and was in the reserves for another six years, rising to the rank of sergeant. He attended a technical school in Oklahoma and later found employment in a body and fender shop in Holbrook. At this time he started to carve his own dolls

and also devoted his creative energy to painting. Some of his paintings are in the Bialac Collection in Phoenix. He has supported himself on carving alone since 1960.

Richard still carves in the style of his father, attaching arms and legs with nails and glue, but he uses polymer for the white undercoat and Hyplar acrylics for colors. The clothing and decorations of his dolls are all painted. After a car accident in late 1986, he was unable to carve for a while, but he is now working on orders again for collectors who admire his carvings.

Tino Youvella

Tino Youvella lives with his wife, Geraldine, and their four sons and three daughters in Polacca, where he was born more than forty years ago. All his sons carve, and Geraldine does most of the wood burning and painting for all of them. Their production is almost like a family business in which every member participates.

Tino started to carve in 1962 when their oldest child was born and he needed the money. He could not find a job in Polacca at the time and agreed to move his family to Phoenix to learn a trade. He worked in Phoenix as an auto mechanic until 1980, when he and his family moved back to Polacca. Over the years Tino had kept up with kachina-doll carving, and Geraldine helped him paint his dolls. Now his sons and he produce action dolls that resemble those of the 1960s and 1970s in stance and movement but that have no organic material ornamentation. Instead they are partially stained and painted with acrylics. Tino carves separate pieces for the arms and often also

Tino Youvella while carving kachina dolls

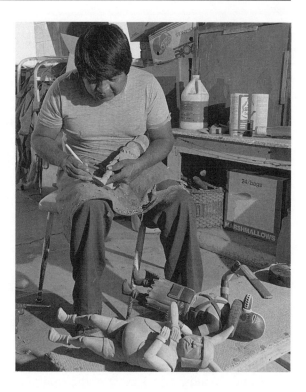

for the legs. He carves pieces for the heads and the feathers separately and glues them onto the body of the doll. Decorations of the costume, ruffles, and other textures are indicated with the woodburning iron before they are stained and painted. He sells his dolls, which generally stand twelve to fourteen inches tall, including the attached base, to Chester Lewis in Holbrook, Bruce McGee in Keams Canyon, a number of traders from New Mexico, and occasionally to the Heard Museum and to collectors who come to him directly. Tino is very active in community work with Alcoholics Anonymous. He is also a farmer and participates in the kiva activities of his village.

A Summary

The purpose of the photographic documentation that led to this book was to record the changes in Hopi kachina-doll carving that took place in the last four years of the 1980s, though in the book itself I have sought to trace the development of the kachina doll and the techniques of its manufacture from the nineteenth century to the present. During the course of my research, it became clear that within the last few years we have witnessed the creation of a new art form: the Hopi kachina wood sculpture.

The art market had a great deal to do with this creation. Its practitioners perceived a need for the form, and Hopi artists were willing to satisfy the new demand. What only decades ago was a craft that required little technical skill lately has developed into an art requiring refined and meticulous techniques.

Kachina dolls were once made solely for religious purposes by anonymous Katsinam and had no monetary value. When Hopi isolation broke down in the nineteenth century, white Americans visited the Hopi Mesas more frequently and began to take an interest in the brightly colored wood figurines they saw there. They knew little, however, about Hopi religion. The kachina dolls they collected were thus removed from the religious realm and came to serve a secular pur-

pose. Each now carried a monetary value based on the aesthetic preferences of the market.

We can speculate that the buyers' tastes at the turn of the century were influenced by nineteenth-century western art, with its widespread realism, but for whatever reason, there is no doubt that the abstract representation of the Hopi Spirits in early kachina dolls was slowly replaced by more realistic renderings, and the wooden figures increasingly represented recognizably human bodies in the act of dancing. Over the decades, Hopi artists carved ever more realistic kachina dolls. In the 1980s these artists—some of them women—created a form of sculpture sold throughout the connoisseur market of the non-Hopi world. Many of the artists have become famous within a few years.

Kachina dolls that fall into the "fine art" category are usually made of a single piece of wood, with feathers and other details carved directly into it. Parts of the figure are left unpainted. Instead the wood is treated with a varnish or preservative to highlight its grain. Most of these dolls stand on a base, also often elaborately carved and signed by the artist. The figures display realistic body proportions and musculature. In general, buyers and collectors have welcomed this change, paying more money for heightened realism. The 1980s brought an accelerated movement toward fine art in Hopi kachina-doll carving. It will be interesting to observe where that movement will lead in the decades to come.

Glossary

Kachina. A small doll that is a representation of a Katsina. It is carved out of cottonwood root.

Katsina. A Spirit Being of the Hopi world.

Katsinam. Plural of *Katsina.*

Katsinmamant. Plural of *Katsinmana.*

Katsinmana. A Katsina Maiden, or female spirit.

Muringputihu. A doll with a cylindrical, very stylized body and a fully carved head. It represents the third stage of fetal development and is made for young girls.

Muringputithu. Plural of *Muringputihu.*

Niman Dance. The ceremony held in July at which the Katsinam appear for the last time before they return to the San Francisco Peaks near Flagstaff. They present the first fruits of the harvest, dance, and distribute gifts.

Powamuya. The ceremony held in February at which the Katsinam appear and at which they distribute gifts, dance, and discipline the Hopi people.

Putsqatihu. A flat kachina doll. It represents the earliest stage of fetal development and is usually made for infants.

Putstihu taywa'yta. A doll with a flat body and a face that is more three-dimensional than that of the putsqatihu. It represents the second stage of fetal development and is made for toddlers.

Tablita. The stepped wooden panel on the head of a Katsina. It is painted in the six directional colors, and its height is increased with imitation corn tassels and the downy feathers of eagles.

Tihu. A kachina doll.

Tithu. Plural of *tihu.*

Bibliography

Adams, E. Charles. *The Origin and Development of the Pueblo Katsina Cult*. Tucson: University of Arizona Press, 1991.

Adams, E. Charles, and Deborah Hull. "The Prehistoric and Historic Occupation of the Hopi Mesas." In Dorothy K. Washburn, ed., *Hopi Kachinas: Spirits of Life*. Seattle: University of Washington Press, 1980.

Brew, J. O. "Hopi Prehistory and History to 1850." In *Handbook of North American Indians*, vol. 9. Washington, D.C.: Smithsonian Institution Press, 1979.

Brody, J. J. "Pueblo Fine Arts." In *Handbook of North American Indians*, vol. 9. Washington, D.C.: Smithsonian Institution Press, 1979.

Clemmer, Richard O. "Hopi Economy and Subsistence." In *Handbook of North American Indians*, vol. 9. Washington, D.C.: Smithsonian Institution Press, 1979.

Colton, Harold S. *Hopi Kachina Dolls*. Albuquerque: University of New Mexico Press, 1959.

———. "What Is a Kachina?" *Plateau* 19 (January 1947): 40–47.

Connelly, John. "Hopi Social Organization." In Dorothy K. Washburn, ed., *Hopi Kachinas: Spirits of Life*. Seattle: University of Washington Press, 1980.

Cosgrove, C. B. "Caves of the Upper Gila and Hueco Areas in New Mexico and Texas." *Papers of the Peabody Museum of American Archaeology and Ethnology* 24, no. 2 (1947).

Dockstader, Frederick J. "Hopi History, 1850–1940." In

Handbook of North American Indians, vol. 9. Washington, D.C.: Smithsonian Institution Press, 1979.

———. *The Kachina and the White Man: A Study of the Influences of White Culture on the Hopi Kachina Cult.* Cranbrook Institute of Science Bulletin 35. Bloomfield, Mich., 1954.

Ferg, Alan. "Fourteenth Century Katchina Depictions on Ceramics." *Papers of the Archaeological Society of New Mexico,* vol. 7. Albuquerque: Archaeological Press, 1982.

Fewkes, Jesse Walter. "Hopi Katcinas, Drawn by Native Artists." *Annual Report of the Bureau of American Ethnology* 21 (1903): 3–126.

———. "Tusayan Katcinas." *Annual Report of the Bureau of American Ethnology* 15 (1897): 251–320.

Frigout, Arlette. "Hopi Ceremonial Organization." In *Handbook of North American Indians,* vol. 9. Washington, D.C.: Smithsonian Institution Press, 1979.

Griffith, James S. "Kachinas and Masking." In *Handbook of North American Indians,* vol. 10. Washington, D.C.: Smithsonian Institution Press, 1983.

Haberland, Wolfgang. "Kachina Figuren der Pueblo Indianer Nord-Amerikas." *Studiensammlung Horst Antes.* Karlsruhe: Badisches Landesmuseum, 1980.

Hack, John Tilton. "The Changing Physical Environment of the Hopi Indians of Arizona." *Papers of the Peabody Museum of Archaeology and Ethnology* 35, no. 1 (1942).

Hackett, Charles. *Revolt of the Pueblo Indians of New Mexico and Otermin's Attempted Reconquest, 1680–1682.* Trans. Charmion Clair Shelby. 2 vols. Albuquerque: University of New Mexico Press, 1942.

Hartmann, Horst. *Kachina Figuren der Hopi Indianer.* Berlin: Museum für Völkerkunde, 1978.

Haury, Emil W. "Excavation of Los Muertos and Neighboring Ruins in the Salt River Valley, Southern Arizona." *Papers of the Peabody Museum of Archaeology and Ethnology* 24 (1945).

Hieb, Louis A. "Hopi World View." In *Handbook of North American Indians,* vol. 9. Washington, D.C.: Smithsonian Institution Press, 1979.

Kennards, Edward A. "Hopi Economy and Subsistence." In *Handbook of North American Indians,* vol. 9. Washington, D.C.: Smithsonian Institution Press, 1979.

Parson, Elsie Clews. *Hopi and Zuni Ceremonialism.* Washington, D.C.: American Anthropological Association, 1933.

Schaafsma, Polly. *Indian Rock Art of the Southwest.* School of American Research, Santa Fe; and the University of New Mexico Press, Albuquerque, 1980.

―――. *Rock Art in New Mexico.* Santa Fe: State Planning Office, 1972.

―――. *Rock Art: The Cochiti Reservoir District.* Papers in Anthropology no. 16. Santa Fe: Museum of New Mexico Press, 1975.

Schaafsma, Polly, and Curtis E. Schaafsma. "Evidence for the Origins of the Pueblo Katchina Cult as Suggested by Southwestern Rock Art." *American Antiquity* 39 (4): 535–45.

Smith, Watson. Kiva Mural Decorations at Awatovi and Kawaika-a. *Papers of the Peabody Museum of Archaeology and Ethnology* 37 (1952).

―――. "Mural Decorations from Ancient Hopi Kivas." In *When Is A Kiva? And Other Questions About Southwestern Archaeology.* Tucson: University of Arizona Press, 1990.

Talayesva, Don C. *Sun Chief: The Autobiography of a Hopi Indian.* New Haven: Yale University Press, 1942.

Tanner, Clara Lee. *Southwest Indian Craft Arts.* Tucson: University of Arizona Press, 1968.

―――. "Contemporary Hopi Crafts: Basketry, Textiles, Pottery, Kachinas." In Dorothy K. Washburn, ed., *Hopi Kachinas: Spirits of Life.* Seattle: University of Washington Press, 1980.

Washburn, Dorothy K. "Kachinas: Window to the Hopi World." In Dorothy K. Washburn, ed., *Hopi Kachinas:*

Spirits of Life. Seattle: University of Washington Press, 1980.

Wright, Barton. *Kachinas: A Hopi Artist's Documentary*. Flagstaff: Northland Press, 1973.

———. *Hopi Kachinas: The Complete Guide to Collecting Kachina Dolls*. Flagstaff: Northland Press, 1977.

Illustration Credits

The Hopi ceremonial calendar (p. 12) is reproduced here courtesy of Barton Wright. The photograph of the earliest recorded wooden artifact resembling a kachina figure (p. 23) and of the sixteenth-century and early-seventeenth-century figures from a kiva mural in Awatovi (pp. 27, 28) are reproduced courtesy of the Peabody Museum of Archaeology and Ethnology at Harvard University. In the color section, the photograph of the Hewtomana kachina doll is reproduced courtesy of Lynn Atkinson of Los Arcos Gallery in Tucson; the photographs of the Tsa'kwaynamuy Siwa'am, Kwaakatsina, and Angwuskatsina kachina dolls are courtesy of the Nadine Mathis Collection; the photographs of the Maahu kachina doll and the Katsinmana sculpture are courtesy of McGee's Indian Art Gallery in Keams Canyon; and the photograph of the Kaasayle Clown is courtesy of the Daniel J. Garland Gallery in Sedona. The Kòoninkatsina kachina doll, the Palhikwmana/Sa'lakwmana sculpture, and the Hotooto sculpture were photographed at the Museum of Northern Arizona's Hopi Artists Exhibition in 1990. All illustrations in this book were reproduced from photographs and transparencies in the photographic collections of the Arizona State Museum.

Index

References to illustrations are in italics. The abbreviations *pl.* and *pls.* refer to the color plates following page 79.

About the Author

Helga Teiwes was born in Büderich, near Düsseldorf, in
Germany, and she learned photography in a Düsseldorf
studio. She earned a master's degree in photography in
1957 and worked as an industrial photographer in Düssel-
dorf until her emigration to the United States in 1960. She
worked in New York City for four years as a commercial
photographer and transparency retoucher and then served
as a field photographer for a large archaeological excavation
at Snaketown in Arizona. Since 1966 Teiwes has held the
position of museum photographer at the Arizona State
Museum at the University of Arizona. Her work at the
museum has included documenting the life of southwestern
Indians, an interest she has also pursued privately for the
past twenty-five years. Her photographs and accompanying
essays have been published nationally and internationally,
she has made two documentary films, and her photographic
study *Navajo* was published by the Swiss publisher U. Bär
Verlag in 1991.